The Alte Nationalgalerie
Berlin

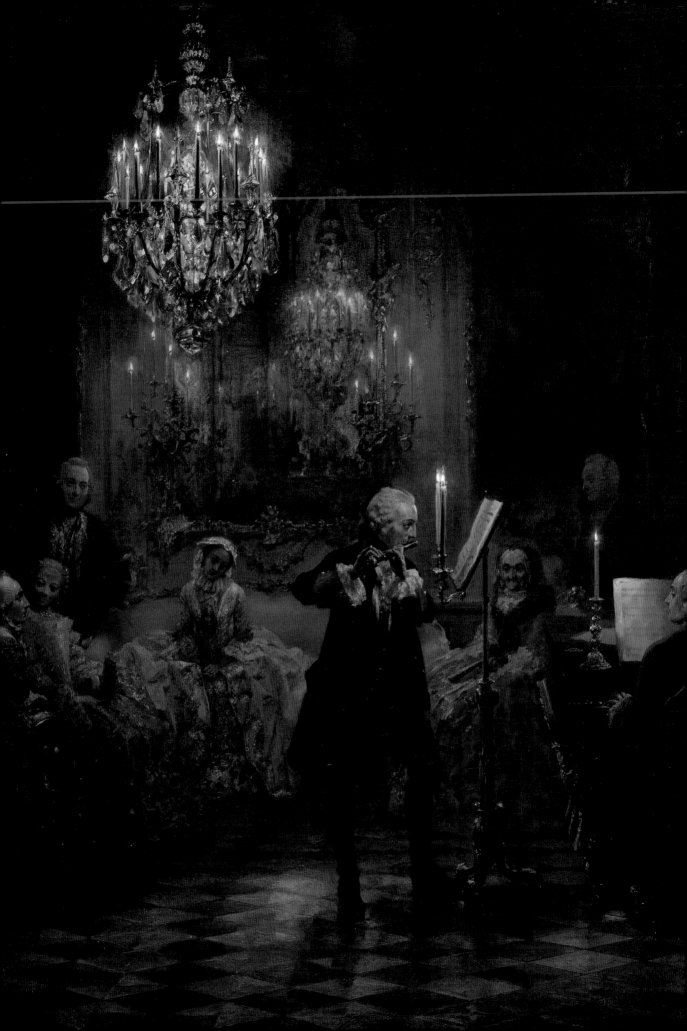

The

Alte Nationalgalerie

Berlin

Edited by Claude Keisch

C.H. BECK/SCALA PUBLISHERS

Front cover illustration: Gottlieb Schick, detail of *Heinrike Dannecker*, 1802

Back cover illustration: Caspar David Friedrich, detail of *Woman at a Window*, 1822

Frontispiece: Adolph Menzel, detail of *The Flute Concert of Frederick the Great at Sanssouci*, 1850–52

© 2005 Scala Publishers Ltd, London
in association with Verlag C. H. Beck oHG, Munich
© 2005 photography: Alte Nationalgalerie, Berlin

First published in 2005 by
Scala Publishers Ltd
Northburgh House
10 Northburgh Street
London EC1V OAT

In association with
Verlag C. H. Beck oHG
Wilhelmstraße 9
80801 Munich

ISBN Scala Publishers 1 85759 337 5
ISBN C.H. Beck 3-406-52675-6

Translation from the original German: Dafydd Rees Roberts
Editorial: Annabel Cary
Design: Andrew Shoolbred and Greg Taylor
Produced by Scala Publishers Ltd
Printed and bound by:
Arti Grafiche, Pomezia-Italia

10 9 8 7 6 5 4 3 2 1

Contents

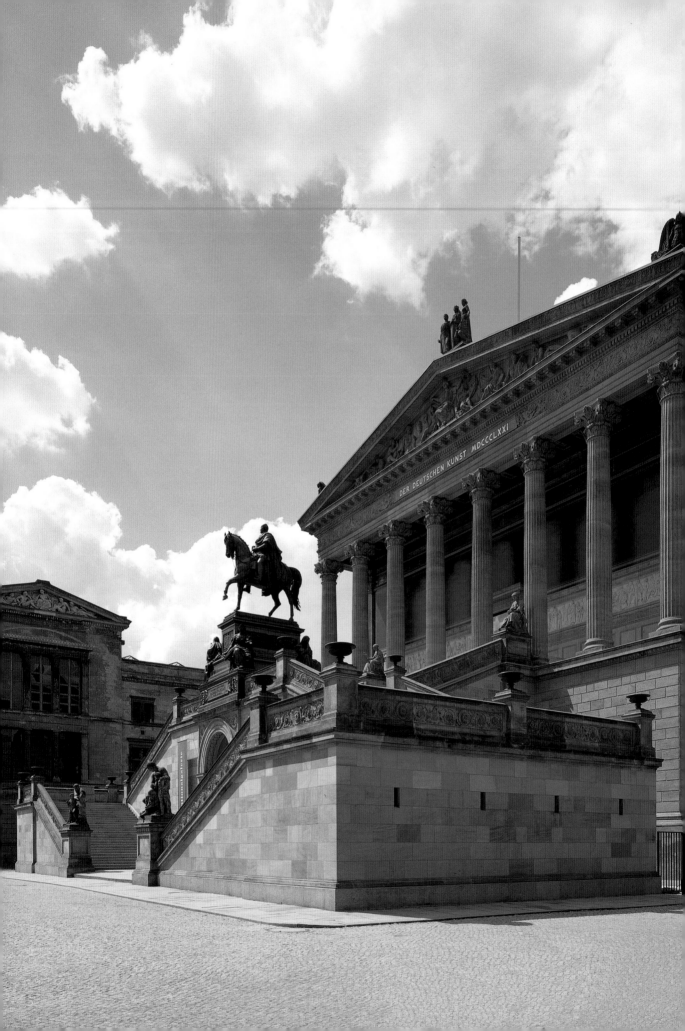

Introduction: The Collection and its Buildings

The Alte Nationalgalerie or Old National Gallery (which includes the Schinkel Museum in the Friedrichswerder Church) is one of three museums comprising the Nationalgalerie. Within this larger institution, which is devoted to art from the late eighteenth century to the present day, the Alte Nationalgalerie focuses on the nineteenth century, although the collection also makes some excursions into earlier and later periods. The two other museums are the Neue Nationalgalerie (New National Gallery, including the Berggruen Collection) and the Museum der Gegenwart (Museum of Contemporary Art), housed in the Hamburger Bahnhof. This spread over three districts of Berlin – Mitte, Tiergarten and Charlottenburg – reflects, on a smaller scale, the wide geographical distribution of the museums of the Stiftung Preußischer Kulturbesitz as a whole.

When one looks at the Alte Nationalgalerie, one is immediately struck by the aesthetic and historical relationship between the collection and the architecture. Built in 1866–76 to plans by Friedrich August Stüler (whose work was completed by Heinrich Strack), the building is a master-piece of late-Berlin neoclassicism before it was overtaken by the neo-Renaissance style. Surrounded by its colonnaded courtyard and presenting splendid façades on every side, it towers over the Museum Island, clearly visible from the banks of the river and beyond. The monumental staircase at the front provides a plinth for an equestrian statue of Friedrich Wilhelm IV, the Prussian king responsible for the whole concept of the Museum Island, which took more than a century to complete. Furthermore, Stüler's design for the Alte Nationalgalerie is based on a sketch by the king for a magnificent building dedicated to the celebration of the arts and sciences.

The suggestive combination of temple (with pedimented façade and half-columns all around), church (with apse) and castle, or theatre (with monumental staircase), reflects a programme also shown in the interior and exterior relief decoration, which today survives only in part; the museum was intended as the aesthetic expression of the unity of art, nation and history. This is especially true of Otto Geyer's frieze on the interior staircase, which offers a broad view of German culture from prehistory to the nineteenth century. While Schinkel's now-lost historical frescoes for the Altes Museum were universal in character, the horizon here is strictly limited to the national.

By about 1900, when the demands of representation began to lose ground to the need for proper lighting for every work, it had become clear that this masterpiece of post-Schinkel architecture did not entirely meet the requirements of a museum. The intrusive internal alterations, carried out on the main floor in 1911–13 and on the floor above in 1936, may thus be

Alte Nationalgalerie, view from the northeast

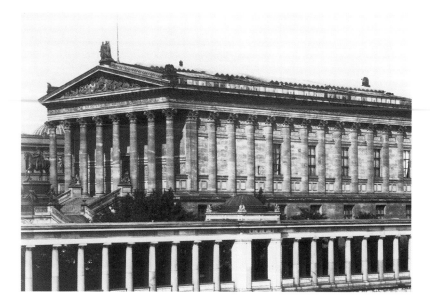

Alte Nationalgalerie,
view from the east,
1901

seen as sacrifices to function. Aside from the technical modernisation of the building, the general restoration of 1998–2001 saw the creation of two new exhibition spaces. This was guided neither by the desire to suppress any part of the museum's building history nor to forget the legacy of the Second World War; irreparable losses were replaced by new schemes, while other areas were refurbished. While the interior of the building was subject to alteration from the very beginning and is now a collage of different periods, the monumental exterior remains practically unchanged.

The discontinuities of architectural style do, however, echo the ruptures marking the history of nineteenth-century art. Moreover, the emphasis, standards of judgement and historical perspectives were shifted repeatedly in the meantime.

Unlike other Berlin museums, the Nationalgalerie does not have its origin in a royal collection. It grew rather from the private collection of Joachim Heinrich Wilhelm Wagener (1782–1861), a Berlin banker and consul of the Kingdom of Sweden and Norway. He donated the 262 paintings he assembled over 45 years to the Prussian Crown, in the hope of contributing to the establishment of a steadily expanding 'National Gallery' of 'more recent', i.e. contemporary, painting. This idea had been under discussion for decades, the debate being particularly lively around 1848. Wagener's will of 16 March 1859 conveniently coincided with the beginning of the short-lived 'New Age' of political liberalism under the Prince Regent, Friedrich Wilhelm, to whom the collection was bequeathed by name. The time was right, and a few weeks after the donor's death in the spring of 1861, the decision was taken to establish the Nationalgalerie.

Although it would take another 15 years before the building could be inaugurated and the paintings could leave their provisional accommodation in the Akademie der Künste on Unter den Linden, by then the scale and composition of the collection had already changed significantly.

In keeping with ideas of civic education, Wagener had for a long time opened his collection to the public and had engaged recognised experts to write catalogues. The museum inherited from him a panoramic survey of recent painting, already known from public exhibitions, which

Peter Cornelius, *Leukothoe,
Klytie and Hyakinthos*, 1819.
Cartoon for the ceiling frescoes
in the Munich Glyptothek

mapped the middle-class tastes of the period. The inclusion of foreign works, particularly by the then-celebrated Belgian painters, showed that the donor's idea of a 'national gallery' had not been limited only to Prussian or even German art. This, though, would soon be forgotten in the early days of Empire; and only just before the turn of the twentieth century did Hugo von Tschudi, the gallery's second director, succeed in again extending the collection beyond the borders of Germany.

Horizons were first extended in other directions. The Wagener Collection's over-emphasis on depictions of everyday scenes was initially counter-balanced by Peter Cornelius's enormous cartoons – preliminary drawings for mythological and religious frescoes for which the extra-high main galleries were built. Soon a large number of neoclassical and neo-baroque sculptures in white marble were added, to stand before and between the black columns of the lower floor. Even today the Nationalgalerie stands out among German collections for the quantity and quality of its sculpture. Finally, a drawing collection was established, which would be joined with the older holdings of the Kupferstichkabinett, but not until more than a century later.

The gilded inscription on the pediment of the building, opened in 1876, reads 'To German Art, 1871', suggesting a national or even nationalistic programme, an idea confirmed inside. Portraits and battle-scenes specially commissioned for the Nationalgalerie were theatrically exhibited against a backdrop of gathered curtains. Yet at the same time, Max Jordan, the first director, bought major works by Menzel, championed controversial artists such as Feuerbach, Böcklin and the sculptor Adolf von Hildebrand, and even consorted with Max Liebermann. It was also during this same period that the Romantic frescoes of the Casa Bartholdy were almost recklessly removed from the walls of their Roman palazzo and installed in the gallery.

The collection's first quarter of a century was thus marked by an unresolved tension, sometimes not even articulated, between the demands of art and of politics; a tension that became intolerable in the period just before 1900. The last decade of the century saw Secessionist artists – first in Munich, and then in Vienna and Berlin, more specifically – proclaim an ethos of artistic

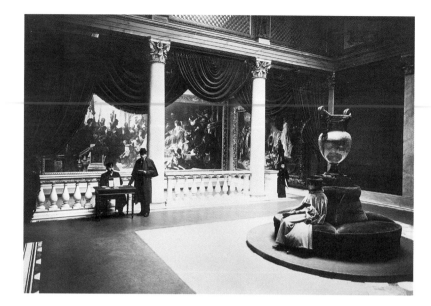

Vestibule on the
third floor, 1897

quality and individuality, and from 1896 onwards, Jordan's disciple Hugo von Tschudi made
efforts to introduce Modernism into the Nationalgalerie. Advised by Max Liebermann and finan-
cially supported by a network of rich Berlin art lovers, he acquired works by the French Impres-
sionists and other painters outside Germany. Among these – demonstratively exhibited as soon as
they were acquired – were works by Manet, Monet and Degas, joined in 1897 by the first of
Cézanne's paintings to find its way into a museum. This was a coup in terms of artistic policy, but
further efforts in this direction were strongly opposed by Wilhelm II, who was using his powers
over the Nationalgalerie, a royal institution, and who finally succeeded (although it took over ten
years) in forcing its director to resign.

The light of Impressionism also fell upon the German art of the past, and hitherto neglected
currents in German and Austrian painting could once again be acknowledged and appreciated.
From Caspar David Friedrich to the early Menzel, from Waldmüller and Leibl to Liebermann,
painterly realism emerged as the true tendency of the century. The *Exhibition of German Art from
1775 to 1875*, held in 1906, was impressive not simply for the vast quantity of works assembled. Like
the Nationalgalerie's acquisitions over recent years, it stood for new values, for 'pure' art and
'painterliness.' It also embodied a corresponding understanding of the history of art; an under-
standing that has since been refined, but even today remains unchanged in its fundamentals. One
result of this was the extension of the historical period covered by the collection, not only into
the future, as might be expected, but also back to the late eighteenth century, when painters like
Anton Graff prepared the ground for the rise of bourgeois realism.

After the dismissal of the all-too-modern Hugo von Tschudi, one might have expected a
return to the old ways. However, his successor Ludwig Justi (director 1909–33) continued to refine
the gallery's image, despite being on better terms with the Kaiser. Alterations to the ground floor
by the architect Ludwig Wille did something to lighten the pomp of the interior, while big battle-
scenes, acquired solely for their subject matter, were transferred to the Royal Armoury, and many

of the portraits went to form a specialised collection, housed in the Bauakademie. In this, the museum was distancing itself from the task of state-building, and was becoming more a 'school of perception', as Justi would call it much later. By the beginning of the First World War, the contours of the later Alte Nationalgalerie – then the only Nationalgalerie – had been fixed. Acquisitions of older artworks were still focused on the Romantics, Biedermeier and on 'painterly' tendencies (the group around Wilhelm Leibl, for example). Until the 1920s efforts were made to afford worthy representations of the legacies of Schinkel and Christian Rauch, but after the World War and the Revolution attention had turned to contemporary art. For this there was no longer enough room in the building. Thus the housing of the contemporary collection in the nearby Kronprinzenpalais saw the establishment of the first 'branch' of the Nationalgalerie. Its fate, as the victim of the National Socialist campaign against 'degenerate art,' belongs to the prehistory of the Neue Nationalgalerie.

The consequences of the Second World War, with its air-raids and the removal of paintings for safekeeping, once again brought the art of the nineteenth and twentieth centuries together in the Nationalgalerie building, which, although heavily damaged, was gradually restored and was usable once again from 1949 onwards. But the collection had not only been decimated by war damage; of what survived, only that half recovered from its hiding places by Soviet troops was available to the gallery. These paintings were exhibited at the old site, together with newly acquired Expressionist paintings and works from the 1920s, alongside the art of the GDR. The other half, under the control of the Western Allies' military administration, formed the basis of a parallel Nationalgalerie in West Berlin, whose collection also extended to the present. This situation was brought to an end with the reunification of Germany. In 1993 the entire holdings of the Old and New National Galleries were consolidated and redistributed, and since the closure in 2001 of the Romantic Collection that was for a time housed in Schloss Charlottenburg, the whole nineteenth-century collection has been shown in the old building on Museum Island.

Today, in the 47 rooms of the three floors of the Alte Nationalgalerie, one can see 450 paintings and sculptures, from the age of Goethe to the Impressionists and the Symbolists. The sculpture collection has unique strengths, for nowhere else can the works of Johann Gottfried Schadow and Adolf von Hildebrand be seen in such quantity or quality. Unequalled too are the frescoes by the Nazarene painters centred around Peter Cornelius and Friedrich Overbeck, taken from the walls of the Casa Bartholdy in Rome; the cartoons of Peter Cornelius; the rooms devoted to Caspar David Friedrich and to Karl Friedrich Schinkel; and the copious and varied collection of works by Adolph Menzel. No visitor will forget the work of the German artists in Rome, or of the Berlin Secession; and certainly not the gallery of French Impressionists, standing at the end of the main axis of the building, which starts at the monumental entrance staircase. It is an axis that suggests a royal road of the imagination that begins in the life of the city, ascends to an elevated artistic idealism and finally arrives at the spirit and the aesthetics of the Early Modern period, the crowning point in the development of nineteenth-century art.

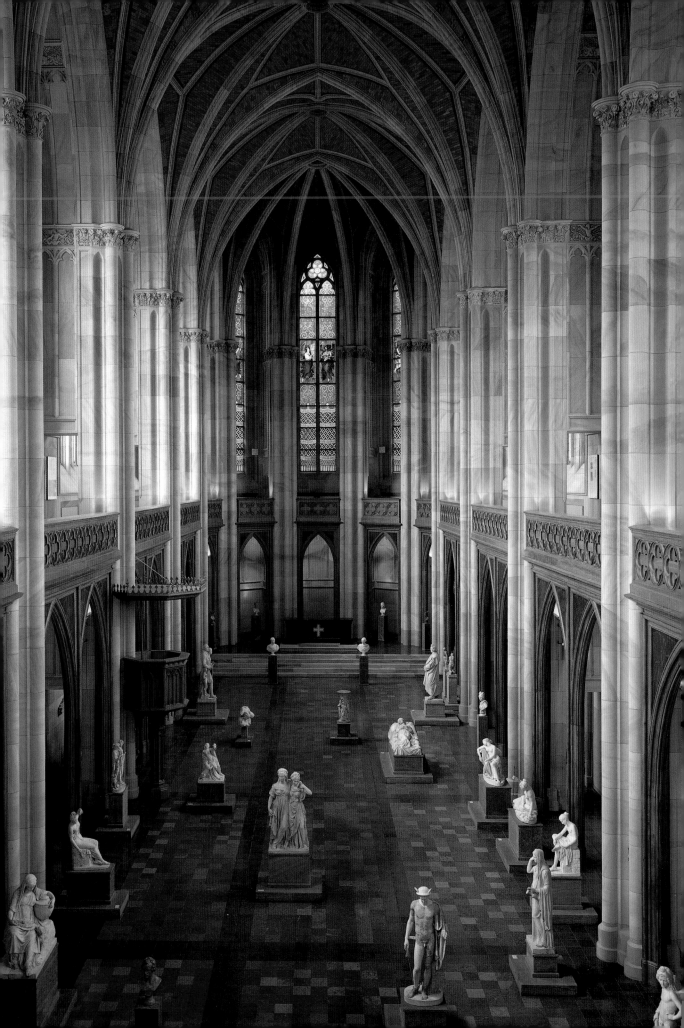

Art in the Age of Goethe

The last decades of the eighteenth century saw the emergence all over Europe of a variety of neo-classical movements, whose common denominator, in those days of radical social and political change, was rejection of the courtly rococo. Inspired by the art of antiquity and guided by the theories of Winckelmann and Goethe, artists as seemingly diverse as Johann Gottfried Schadow, Gottlieb Schick and Bertel Thorvaldsen all sought their ideal of beauty in simplicity, naturalness and harmony. As far-reaching changes took place at every level of society – while the bourgeoisie fought for equality with the aristocracy, and in France the king was violently deposed – visual artists pursued their vision of a classical art in various ways. They were inspired or influenced, not only by the discovery of ruined Greek temples on Italian soil and the excavations at Pompeii and Herculaneum, but also by the Napoleonic Wars that caused French state art to be known through-out large parts of Europe.

Begun in more favourable times, the travels of aristocratic and middle-class tourists in search of ancient sites and works of art were not halted even by 20 years of European war. Both private and princely collections were enriched with antiquities, often restored in the light of the latest archaeological research by sculptors such as Bertel Thorvaldsen, Christian Daniel Rauch and Friedrich Tieck. The study of antique works and their plaster casts was part of the basic training at the academies of fine art.

As early as the second half of the eighteenth century, German artists had established a colony in Rome, a presence that would grow with the passage of time. Not only did Rome offer a substitute for the artistic centre that was nonexistent in a Germany comprising small princely states, but it was also a meeting place for artists and thinkers from all over Europe – a focus for international exchanges. It was there that the art historian Winckelmann and the painter Anton Raphael Mengs began their friendship that was so pregnant with consequences. Jakob Philipp Hackert, the most significant German landscape painter of the late eighteenth century, had gone to live there in 1768 before moving to Naples. He painted *vedute,* but also idealised landscapes. Among the next generation was Joseph Anton Koch, whose work – mostly created in the Sabine Mountains, east of Rome – would be an important influence on younger German artists. His almost timeless landscapes emphasise the greatness of nature: the contrasts between the idyllic and the sublime. At first, Koch was represented in the Nationalgalerie only by his *Monastery of San Francesco di Civitella*, but Max Jordan, the first director, was already looking to fill the gaps in the collection, and in 1887 he presented Koch's *Waterfalls at Subiaco* to the gallery.

Friedrichswerder Church, interior

The importance of bourgeois portraiture in this period is today clearly reflected in the collection, thanks to donations and strategic purchases. There is, for example, a striking group of highly expressive portraits by Anton Graff, the most significant German portrait-painter of the Enlightenment. Freed from the conventions of the baroque ceremonial portrait, he penetrated deeply into the characters of his mostly middle-class subjects. Henriette Herz, whom Dorothea Therbusch had a few years earlier depicted in the role of an antique Hebe, appears in his portrait in simple housewife's dress – self-assured and radiating warmth. And while Johann Friedrich August Tischbein's *Lute Player* has not yet broken with the rococo tradition, with the fabric of the lute player's dress being so delicately rendered, Gottlieb Schick's portrait of *Heinrike Dannecker*, despite its antique aspects, embodies a distinctly modern view of humanity, whose association with social revolution is clearly signalled.

Even more imposing than the paintings are the neoclassical sculptures, of which the Nationalgalerie has an exceptionally large collection. Towards the end of the nineteeth century, the extensive artistic estates of the sculptors Johann Gottfried Schadow and Christian Daniel Rauch were acquired. As it was not possible to show all the important works in the Museum Island building, Karl Friedrich Schinkel's Friedrichswerder Church was converted into a sculpture museum, which presents the development of neoclassical sculpture in Berlin from 1780 to 1860. There one can see busts and full-length sculptures by Johann Gottfried Schadow and his son Ridolfo, and works by Christian Friedrich Tieck, Christian Daniel Rauch, Friedrich Drake and Theodor Kalide.

The lower transverse hall of the Nationalgalerie is also devoted purely to sculpture. The *Hebe* of the then-celebrated Italian sculptor Antonio Canova embodies a tender ideality derived from the Hellenistic example. The Danish sculptor Bertel Thorvaldsen, on the other hand, who worked in Rome for decades, turned to classical Greek models. Goethe forcefully defended this idealising tendency in neoclassicism, engaging in a sensational polemic with the Berlin sculptor Johann Gottfried Schadow. His works are marked by a sense of realism and closeness to nature, maintaining a particularly felicitous balance between the older ideas of grace and the demand for truthfulness: a vivid realisation of Schiller's coupling of 'grace and dignity.'

The realistic trend in Berlin neoclassicism was further developed in the extensive œuvre of Christian Daniel Rauch, which here represents the late phase of neoclassical sculpture. But even in his own lifetime and before the inauguration of his equestrian statue of Frederick the Great in the centre of the expanding Prussian capital, Theodor Kalide's *Bacchante on a Panther*, whose sensuality recalls Hellenistic art, had put into question a constricting and increasingly desiccated interpretation of the classical.

Brigitte Schmitz

1

Anton Raphael Mengs
1728 Aussig, Bohemia–1779 Rome
Self-portrait, c.1773/74
Oil on wood, 90.5 × 74.5 cm
Purchased in 1941 from a private
owner in Berlin

Mengs – an influential painter, art
theorist and director of the Madrid
Academy – returned several times
to this painting, produced in 1773
for the gallery of self-portraits at
the Uffizi in Florence. The artist
presents himself in a self-confident,
somewhat rhetorical attitude,
holding a brush and a portfolio
of drawings. His contemporary,
Winckelmann, was an extremely
important influence on the early
development of neoclassicism.

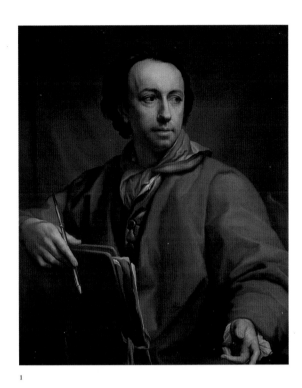

1

2

**Johann Friedrich August
Tischbein**
1750 Maastricht–1812 Heidelberg
Lute Player, 1786
Oil on canvas, 127 × 98 cm
Purchased in 1883 from the Berlin
art dealer F. O. Hesse

A portraitist much in demand not
only in Germany but also at all
the courts of Europe, Tischbein
painted this beautiful and charm-
ing lute player at The Hague,
although her identity is unknown.
The portrait is still marked by the
rococo style whose time was
coming to an end.

2

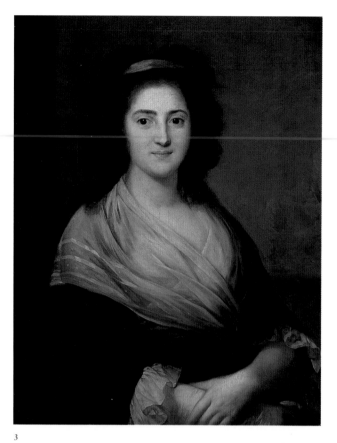

3

3
Anton Graff
1763 Winterthur–1813 Dresden
Portrait of Henriette Herz, 1792
Oil on canvas, 83 × 65 cm
Purchased 1889 from Eugenie
Schadow, née d'Alton-Rauch in
Berlin

The then 29-year-old wife of the
Jewish physician Marcus Herz
held a salon in Berlin, which was
inspired by the spirit of tolerance
and Enlightenment. Graff, the
great portraitist of the bourgeois
elite of Goethe's time, has shown
her in simple housewife's dress,
emphasising her tender, warm-
hearted expression.

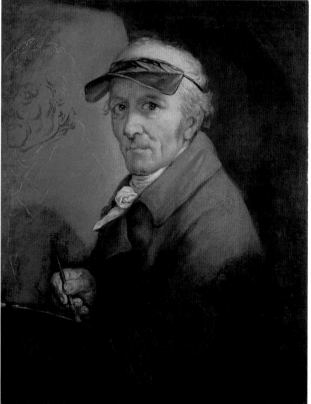

4

4
Anton Graff
1763 Winterthur–1813 Dresden
Self-portrait with Eye-Shade, 1813
Oil on canvas, 65 × 51 cm
Purchased 1881 from Kunsthand-
lung Börner, Leipzig

Highly regarded in both court and
middle-class circles, Graff painted
his own portrait numerous times.
The Nationalgalerie possesses two,
one from his early years and this,
from the last year of his life.

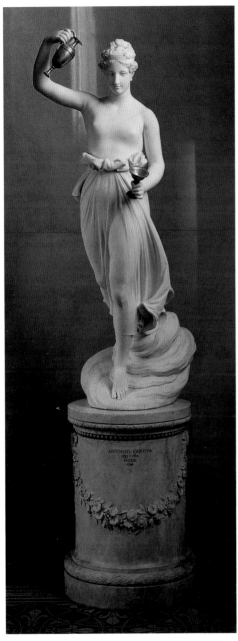

5

6

Antonio Canova
1757 Possagno–1822 Venice
Hebe, 1796
Marble, 160 × 65 × 85 cm
In the Königlichen Antikensamm-
lung since 1830; transferred to the
Nationalgalerie in 1878

Canova, the master of early neo-
classical sculpture, gives the marble
the lightness of an ethereal appari-
tion; floating on a cloud, the god-
dess of youth pours ambrosia, the
drink of eternal life, at the table of
the gods. This, the first of several
marble versions, saw the sculptor
celebrated as a new Pheidias.

Bertel Thorvaldsen
1770–1844 Copenhagen
Psyche, 1806
Marble, 129 × 38 × 39 cm
Transferred to the Nationalgalerie
in 1949

The Roman poet Apuleius' story of
Cupid and Psyche was widely read
around 1800. Thorvaldsen shows
Psyche alone, not as is usually the
case, as one of a youthful couple,
and despite her butterfly wings his
Psyche is simply standing on her
own two feet. She embodies the
hopes and desires of the human
soul. The ointment jar derives
from the story: its contents will
send her into a death-like sleep
from which she will be saved by
her lover, Cupid.

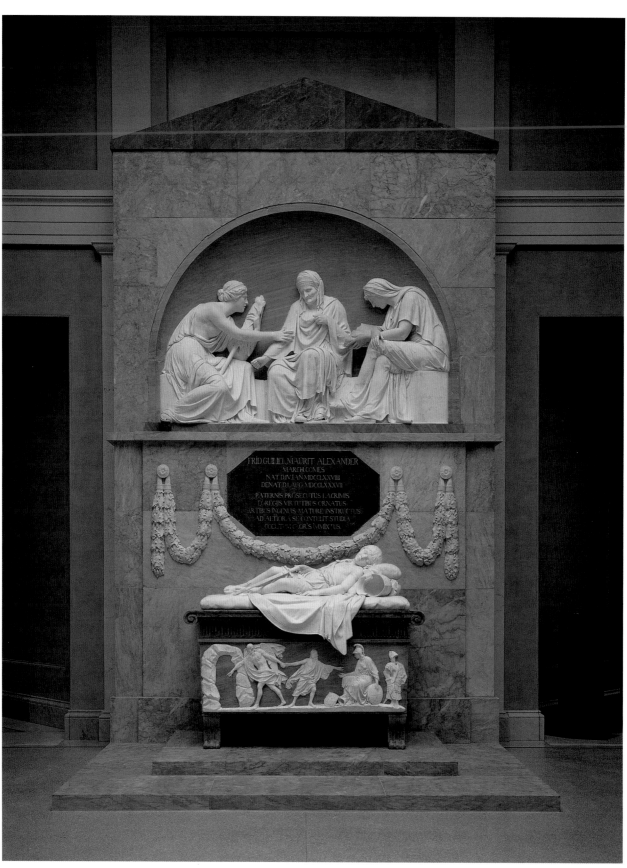

7
Johann Gottfried Schadow
1764–1850 Berlin
Monument to Count Alexander von der Mark, 1788–90
Marble, 623 × 370 cm
Long-term loan of the Evangelical Parish of Friedrichswerder zu Berlin

When Alexander, Count of the Mark – a son of Friedrich Wilhelm II of Prussia and of his lover the Countess Lichtenau – died in childhood in 1797, the King had a memorial erected to him that, after the Second World War, was recovered from the destroyed Dorotheenstadt Church. The young Schadow offered an impressive interpretation of the newly rediscovered antique idea of death as sleep. Despite this idealisation, the lively naturalness of the work makes it one of the most magnificent funerary monuments of European neoclassicism.

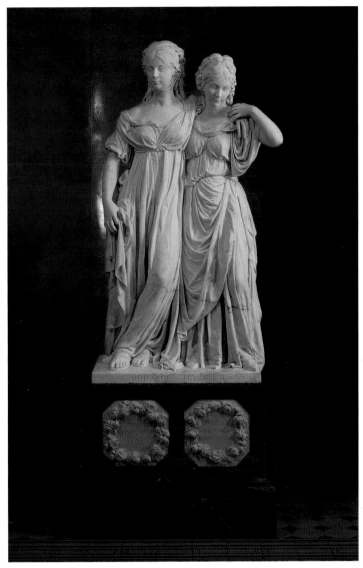

8

8
Johann Gottfried Schadow
1764–1850 Berlin
Princesses Luise and Friederike of Prussia, 1795–97
Marble, 172 × 94 × 59 cm
Transferred from the Berliner Stadtschloss in 1949

This life-size group commissioned by King Friedrich Wilhelm II of Prussia shows Crown Princess Luise of Prussia (1776–1810) affectionately embracing her younger sister Friederike (1778–1841). The fine drapery clings closely to their limbs, and the composition of the group also has its models in antiquity. In the enchanting freshness and beauty of these figures, in which his characteristic fusion of baroque sensuality and neoclassical understanding is combined with precise observation and deft characterisation of his subjects, Schadow here reached the zenith of his artistic career.

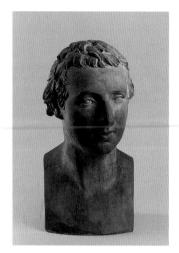

9

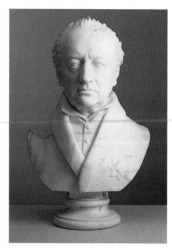

10

9
Johann Gottfried Schadow
1764–1850 Berlin
*Self-portrait, c.*1790/94
Terracotta, 41 × 22 × 25 cm
Purchased in 1917 from Adelheid
Kaibel, née Schadow, Göttingen

Always striving for the natural,
Schadow did not allow himself
any self-idealisation. Appointed as
sculptor to the Prussian court at
the age of 23, he presents himself
here as active and self-assured,
attentively observing his surround-
ings. The narrow base of the bust
leads the eye to the facial features,
which are full of individuality.

10
Johann Gottfried Schadow
1764–1850 Berlin
Johann Wolfgang Goethe, 1822/23
Marble, 59 × 36 × 24 cm
Purchased in 1887 from Eugenie
Schadow, née d'Alton-Rauch

This was one of Schadow's last
sculptures. As the poet had refused
to sit for him, he worked from a
life-mask taken in 1807. This is not
a celebration of timeless poetical
genius, like Rauch's heroic, bare-
shouldered Goethe, but the portrait
of a Weimar minister, sober and
almost starchy.

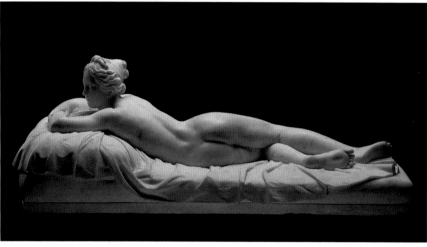

11

11
Johann Gottfried Schadow
1764–1850 Berlin
Young Woman Reclining, 1826
Marble, 34 × 95 × 38 cm
Purchased 1865 from Eugenie
Schadow, née d'Alton-Rauch

This was the sculptor's last marble
work, before a lack of commissions
and impending blindness forced
him to give up working in stone.
The pose of the nameless female
model is taken from a famous
antique figure of a hermaphrodite,
but no ancient myth or more
recent anecdote is associated with
the work.

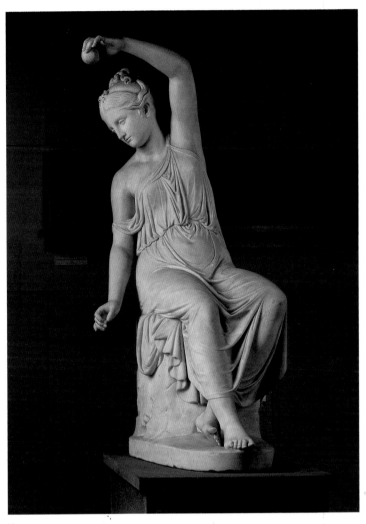

12

12
Ridolfo Schadow
1786–1822 Rome
The Spinner, 1816–18
Marble, 125 × 58 × 77 cm
Transferred to the Nationalgalerie
in 1949. Exhibited in the Friedrichs-
werder Church

Johann Gottfried Schadow's eldest
son, who lived in Rome from 1811,
was lastingly influenced by Bertel
Thorvaldsen. In 1816 Ridolfo
created the first of several versions
of this charmingly delicate figure,
who sits on a rock, spinning
thread to kill time; unlike many
neoclassical mythological figures,
this is an anonymous genre subject
without narrative associations,
thus pointing towards Biedermeier
painting. One of the attractive
daughters of the widow Buti is
said to have sat as the model.

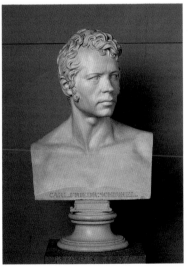

13

13
Christian Friedrich Tieck
1776–1851 Berlin
Karl Friedrich Schinkel, 1819
Marble, 67 × 38 × 26.5 cm
Transferred to the Nationalgalerie
from the Altes Museum in 1923

The Berlin architect, town planner
and painter (1781–1841), who
stamped his mark on neoclassical
Berlin, is depicted here unclothed
and therefore non-attributable
to any particular period of time.
During his early years in Italy
Tieck developed a strict neo-
classical style that he maintained
even after his return to Berlin.

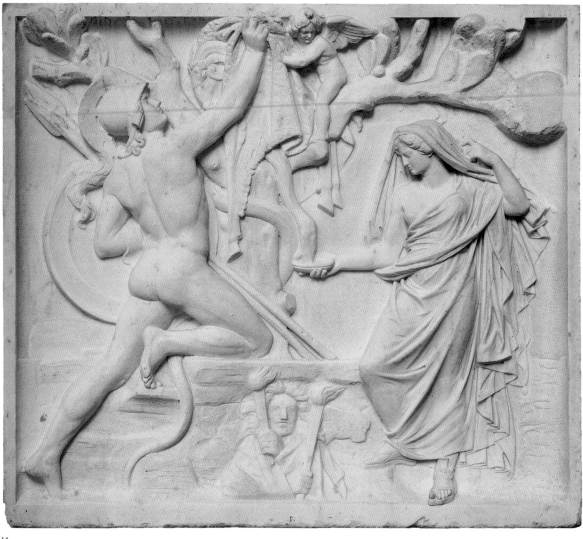

14

14
Christian Daniel Rauch
1777 Arolsen–1857 Dresden
*Jason, Aided by Medea, Carrying off
the Golden Fleece*, maquette 1810,
sculpture begun in 1818, unfinished
Marble, 128 × 140 × 21 cm
From the estate of the artist.
Exhibited in the Friedrichswerder
Church

This is a scene from the ancient
legend of the Argonauts: the hero
Jason, helped by King Aietes'
daughter Medea, carries off the
Golden Fleece from Colchis. Rauch
was presumably inspired by Bertel
Thorvaldsen's great statue of Jason,
completed in 1802.

15
Christian Daniel Rauch
1777 Arolsen–1857 Dresden
Bertel Thorvaldsen, 1816
Marble, 72 × 45 × 35 cm
Purchased 1940

Rauch enjoyed a lifelong friendship with the great Danish sculptor Bertel Thorvaldsen (1770–1844), whom he had met in Rome. He portrayed him twice: in May 1812, in a strictly formal style; and in the late autumn of 1816, in a much more lively fashion, with the head turned sideways. This second sculpture in plaster served for the marble version in the Nationalgalerie.

15

16
Christian Daniel Rauch
1777 Arolsen–1857 Dresden
Funerary Sculpture of Queen Luise of Prussia, second version (detail), 1812–27
Marble, 65 × 220 × 96 cm
On loan from the Stiftung Preußische Schlösser und Gärten Berlin-Brandenburg. Exhibited in the Friedrichswerder Church

This is a second version of the figure on the tomb of the oft-praised and greatly mourned Queen Luise. After her death in July 1810, Friedrich Wilhelm III had a mausoleum built for her at Charlottenburg, and Schinkel's neo-Gothic architecture houses the monumental, recumbent figure of the mother of the nation that made its young sculptor famous. Moved by a sense of missed artistic opportunities, Rauch worked until 1827 on a second version, in which the queen is shown much more relaxed and less close to death. The clothing more clearly models the form of the body, and unlike the formal memorial in Charlottenburg, this version conveys a sense of Luise being both wife and mother.

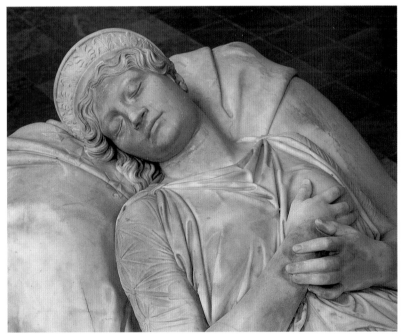

16

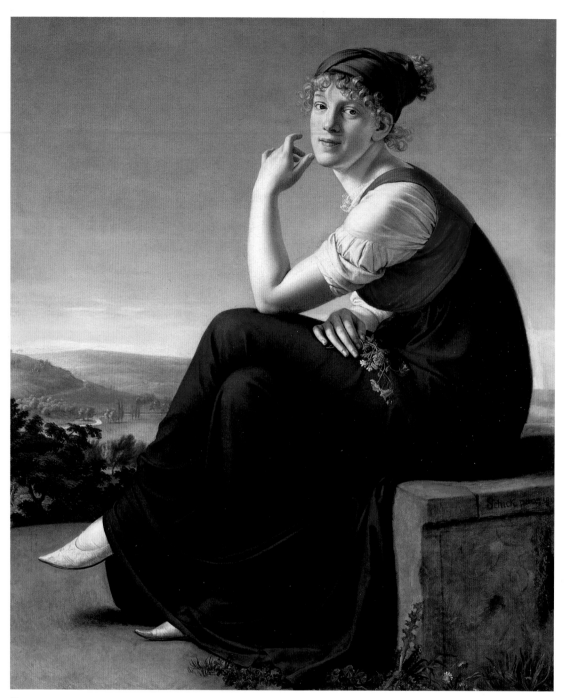

17

17
Gottlieb Schick
1776–1812 Stuttgart
Heinrike Dannecker, 1802
Oil on canvas, 119 × 100 cm
Purchased in 1934 from Frau E.
Graubner, Frankfurt/Main

The wife of Stuttgart sculptor
Johann Heinrich Dannecker is
shown sitting in front of a broad
landscape, turning towards the
viewer with a friendly air. In the
dress of this 29-year-old woman

we see the colours of the French
tricolour. Schick, who had trained
for many years with Jacques-Louis
David in Paris, borrowed the
composition of the painting from
classical Greek reliefs.

18
Christian Daniel Rauch
1777 Arolsen–1857 Dresden
Seated Victory with Laurel Wreath,
1838–45
Marble, 223 × 106 × 90 (inc. wings)
1951, from the Berliner Stadtschloss

Rauch and his pupils produced
several goddesses of victory
throwing laurel wreaths, which
celebrated Prussia's part in the
defeat of Napoleon. For Friedrich
Wilhelm IV Rauch repeated a figure
he had sculpted for the Valhalla
near Regensburg in 1834–41. This
was placed in the White Room,
the throne room of the Berliner
Stadtschloss, where it remained
until the building was demolished.

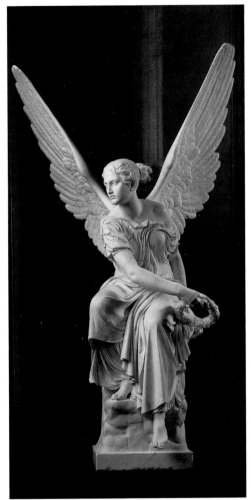

18

19
Theodor Kalide
1801 Königshütte–1863 Gleiwitz
Bacchante on a Panther, 1844–48
Marble fragment, 71 × 123 × 52 cm
Purchased in 1878 from Herr
Schaller, Sorau. Exhibited in the
Friedrichswerder Church

The portrayal of such unbridled
sensuality seemed inconsistent
with both bourgeois morality and
the rigorous stylistic norms of the
Berlin school of sculpture led by
Rauch, and for similarities one
must search among some of the
French Romantics. One of the
most extraordinary works of
German 19th-century sculpture,
only this highly expressive
fragment survived the Second
World War.

19

20

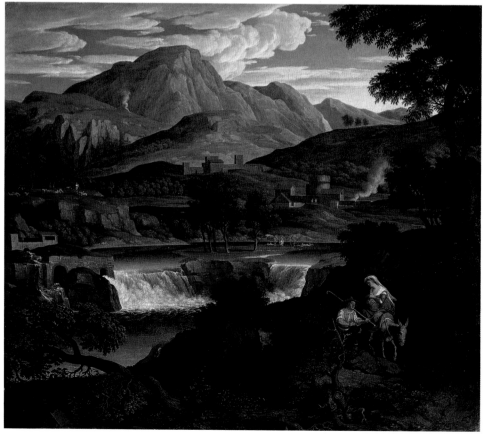

21

20

Josef Anton Koch

1768 Obergiblen, Tyrol–1839 Rome
Monastery of San Francesco di Civitella, 1814
Oil on Wood, 45 × 57 cm
Purchased 1876

Koch's patron, von Asbeck of Munich, commissioned this painting as a pendant to the *Wine-Growers' Celebration at Olevano* (Munich, Neue Pinakothek), completed two years earlier. The Olevano landscape so favoured by the artist unfolds through a succession of planes – from the idyllic, populated countryside to the lonely and forbidding mountains in the distance.

21

Josef Anton Koch

1768 Obergiblen, Tyrol–1839 Rome
Waterfalls at Subiaco, 1812/13
Oil on canvas, 58 × 68 cm
Bequest of Max Jordan, Berlin, 1887

This view of the Italian landscape was painted during a three-year stay in Vienna. The eye looks down over a shepherd family – probably a reflection of the Holy Family – to then rove freely over the valley of the River Anio and up to the lofty and timeless heights of the Sabine Mountains.

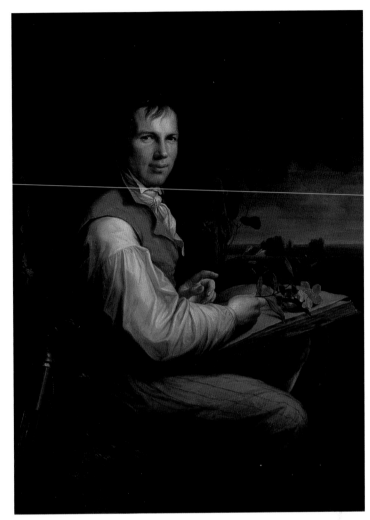

22

22

Friedrich Georg Weitsch

1758 Braunschweig–1828 Berlin
Alexander von Humboldt, 1806
Oil on canvas, 126 × 92.5 cm
In the Nationalgalerie since 1861, on long-term loan from King Wilhelm I; transferred in 1934

The famous scientist Alexander von Humboldt (1769–1859) is here portrayed as a botanist in an idealised primeval forest. In his right hand he holds a freshly cut *Alstroemeria* flower. The painting was created two years after Humboldt's return from his five-year-long research trip through South America.

23

23
Jakob Philipp Hackert
1737 Prenzlau–1807 San Pietro
di Careggi, Florence
Landscape with River, 1805
Oil on canvas, 64.5 × 96 cm
Bequest of Lieut.-Col. a.D.
Behrendt, Berlin, 1907

As well as faithful portrayals of
landscapes, this painter – who
lived in Italy from 1768 – also
painted idealised compositions
derived from the free combination
of studies from nature. His ideal
of harmonious landscape was tho-
roughly indebted to neoclassicism.

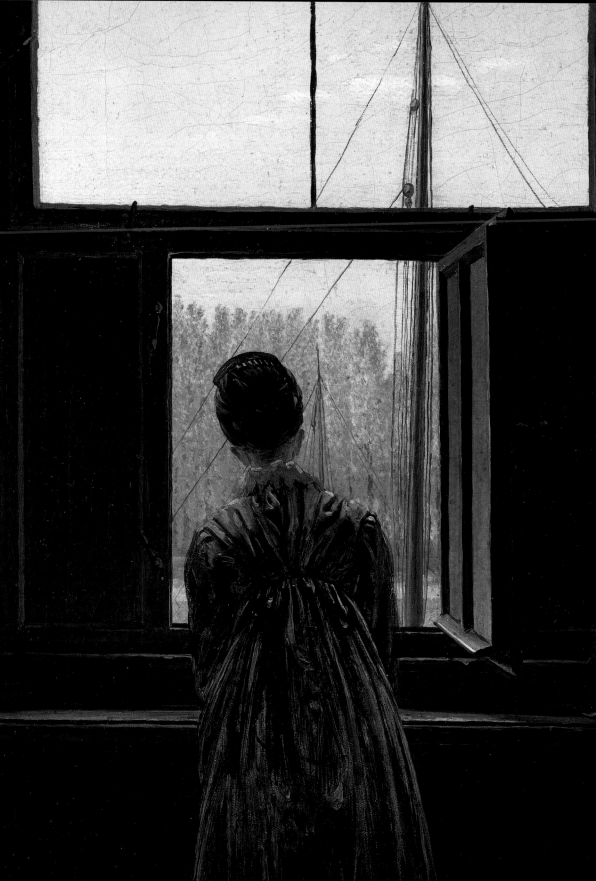

Romanticism

On the top floor of the Nationalgalerie, one can admire one of the most valuable and extensive collections of German Romantic art. Thanks to its founder, Wagener, the Nationalgalerie has had a number of important Romantic works since 1861, among them Caspar David Friedrich's *The Solitary Tree* and *Moonrise over the Sea*, as well as 11 paintings by Karl Friedrich Schinkel. Decades later, when Hugo von Tschudi was director between 1896 and 1908, Romantics like Caspar David Friedrich, Philipp Otto Runge, Karl Friedrich Schinkel and Carl Blechen were all rediscovered. What Tschudi felt was important in their landscape painting was the individual appropriation of reality. In 1906 the exhibition of 100 years of German art at the Nationalgalerie played an important part in the rediscovery and reappraisal of the Romantics. Caspar David Friedrich's work moved Tschudi with its '... melancholy tone; the mystical exhilaration ... or the Ossianic mood of the lonely figure standing on bright dune sand, dreaming into the infinity of a deep black sea....' As a result of the exhibition, an exceptional grant from the government made it possible to acquire several paintings by German Romantics, among them Friedrich's *Woman at a Window*.

Ludwig Justi, Tschudi's successor as director between 1909 and 1933, also enriched the collection due to his acquisition of many early nineteenth-century works. Even more than his predecessor, he had a particular sympathy for the Romantics. Justi was convinced that art was a creation of spiritual values: 'Where the artist's invention does not spring from form but from experience, turning experience into form, then every work is created entirely anew. A good number of Friedrich's paintings hang in the National-Galerie: every one of them offers a particular, unique vision, an individual, unforgettable mood.'

Today Caspar David Friedrich's paintings form the climax of any tour of the gallery's top floor. Friedrich sought to communicate reverence for nature as a meditative experience. He freed the portrayal of landscape from the received categories, of faithful 'views' on the one hand and invented ideal landscapes on the other. For Friedrich, art could come only from vision and imagination; only the inward eye could produce Romantic landscape art, the dream-like articulation of human longing. Friedrich's paintings mirror like no others the experience of the epoch-making dissolution of received ways of seeing the world, which took place around 1800. His inventive power and unique pictorial language reveal the new, modern, subjectively oriented artistic ideal of self-interrogation and self-thematisation.

No doubt influenced by Friedrich, Karl Friedrich Schinkel turned to landscape painting early on. His taste for the historical and the narrative, for old German subjects and Gothic architecture,

Caspar David Friedrich, detail of *Woman at a Window*, 1822 (cat. 30)

was not least the result of his friendship with such Romantic poets as Clemens Brentano and Achim von Arnim. In 1813 Schinkel began a series of paintings of Gothic cathedrals, which continued in 1815 with *Medieval City on a River*. These cathedral paintings reflected the political and spiritual situation in Germany. The collapse of the Holy Roman Empire and the foreign domination of the German lands, which followed defeat by Napoleon, led the Romantic generation to elevate the German Middle Ages into an ideal of national unity and strength, an embodiment of their hopes for the present. From the 1820s onward, Schinkel – whose work embraced architecture, the preservation of historical monuments, theatre design, the design of furniture and ironwork, and painting – distanced himself more and more from these Romantic ideals. In 1825 he painted his most monumental picture, *A Glimpse of Greece's Golden Age*, a neoclassical profession of faith.

Carl Blechen is now considered to be one of the outstanding talents of nineteenth-century German art. In a creative life spanning only 15 years (1823–38), he succeeded in giving expression to his own Romantic temperament, attracted by all things uncanny and fantastic, and he achieved brilliance as a painter through his improvisational use of translucent colour, bolder by far than his contemporaries. In 1824, on Schinkel's recommendation, Blechen obtained employment as a scene-painter at the Königstädtische Theater. Inspired by the fairy-tale, fantastical world of the stage, during this period he created the most darkly melancholic of compositions. The sale of his painting, *A Semnonian Camp*, allowed Blechen to finance a journey to Italy in 1828. Conceived as an opportunity for study, it was rather a period of intense creativity, significantly influenced by contemporary *plein-air* painting, such as the spontaneous and unconstrained approach of Turner, whose work he was able to see in Rome. Blechen returned to Berlin from Italy in 1829, bringing with him a mass of work. With this achievement, properly appreciated by only a few of his contemporaries, a new phase in Blechen's life began, which, however, took on an increasingly tragic aspect in the face of misunderstanding and hostile criticism. Only in the twentieth century did the boldness of his light-bathed landscapes, which pointed the way to Impressionism and Modernism, win him the recognition he deserved.

Alongside the paintings of Friedrich, Schinkel and Blechen, the works of the so-called Nazarenes are another important strength of the Nationalgalerie's collection. The two large galleries on the main floor were originally intended to accommodate more than 70 large-format cartoons by Peter Cornelius, only a selection of which are exhibited today. Besides these, the Nationalgalerie owns murals from the Casa Bartholdy in Rome, an important early masterpiece of Nazarene monumental art.

Birgit Verwiebe

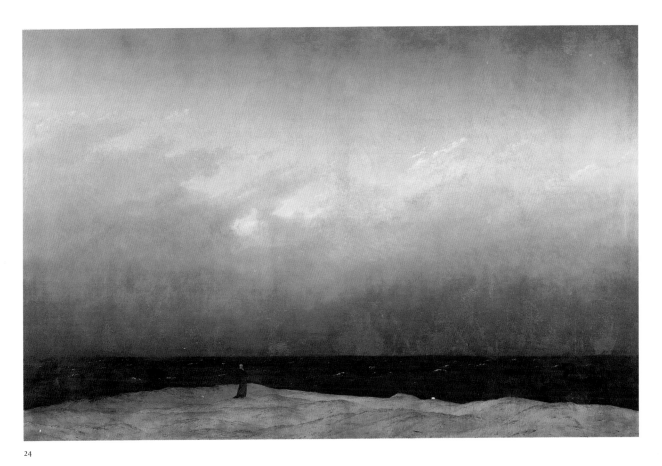

24

24
Caspar David Friedrich
1774 Greifswald–1840 Dresden
Monk by the Sea, 1808–10
Oil on canvas, 110 × 171.5 cm
From the now demolished Berliner
Stadtschloss

Caspar David Friedrich worked for two years on this, his most famous painting, and after several changes and much overpainting he achieved an unparalleled simplification through the radical reduction of the number of objects depicted. There had originally been two ships on the sea and fish-traps at its edge. These were removed and the final version shows the monk alone before an immeasurable expanse of dark sea. The pictorial space offers no limits and there is no resting point for the eye. Friedrich showed this painting – together with its pendant, *Abbey in the Oakwood* – at the Berlin Academy exhibition in 1810, where it was bought by King Friedrich Wilhelm III.

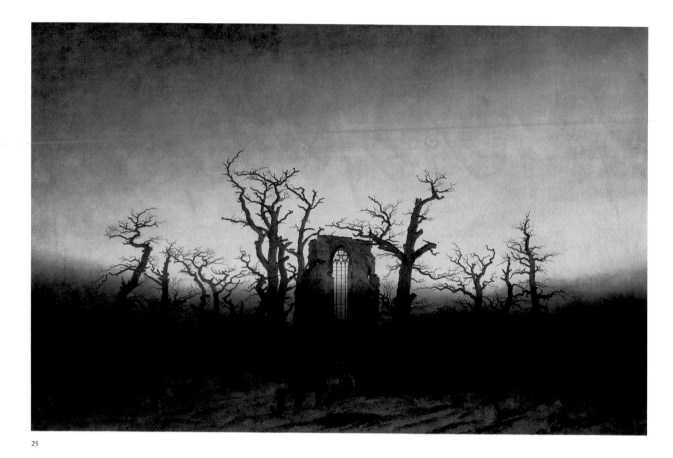

25

25
Caspar David Friedrich
1774 Greifswald–1840 Dresden
Abbey in the Oakwood, 1809–10
Oil on canvas, 110.4 × 171 cm
From the now demolished Berliner
Stadtschloss

Abbey in the Oakwood was also
bought by the king. Both these
key works of German Romantic
painting are characterised by an
enigmatic sense of reverie and an
unusual radicalism of form. In
Monk by the Sea, Man stands facing
the infinity of Nature, meditating
on life and its limits. Its pendant is
concerned with death and the
hereafter: here monks are carrying
a coffin through a snow-covered
churchyard to celebrate the funeral
mass at an abandoned Gothic ruin.
Like gestures of lament, bare oak
trees rise against a sky that glows
with the last light of evening. Carl
Gustav Carus praised this as 'the
most profoundly poetic of all
recent landscape painting.'

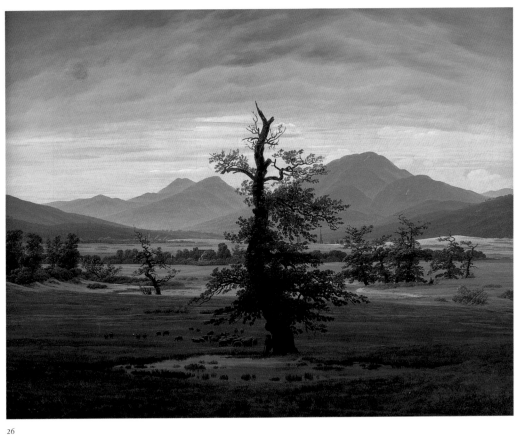

26

26
Caspar David Friedrich
1774 Greifswald–1840 Dresden
The Solitary Tree, 1822
Oil on canvas, 55 × 71 cm
Acquired in 1861 as part of the
Wagener Bequest

In 1822 Friedrich painted a pair of pictures representing contrasting times of day, for Wagener, the Berlin banker whose art collection would form the basis of the Nationalgalerie. Groups showing different seasons or times of day are often to be found in his work, since for him, as for other Romantic artists, the passage of time symbolised the journey from birth to death. Morning is represented here by a meadow landscape with ponds, coppices and villages. At the centre of the composition is a towering, monu-mental oak tree, at whose foot is a shepherd with his flock. The massive tree stands for vitality and strength, but the branches at its crown have already died off.

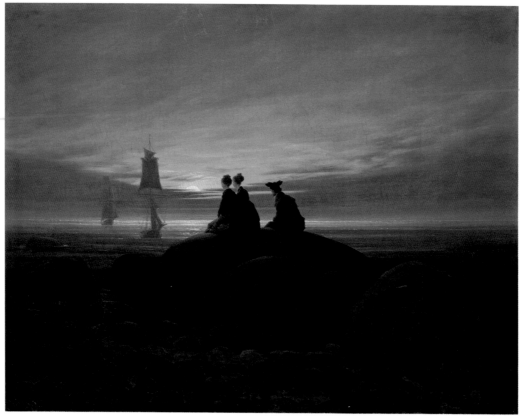

27

27
Caspar David Friedrich
1774 Greifswald–1840 Dresden
Moonrise over the Sea, 1822
Oil on canvas, 55 × 71 cm
Acquired in 1861 as part of the
Wagener Bequest

Moonrise over the Sea was painted as the evening counterpart to *The Solitary Tree*. Two women and a man are sitting on a rock by the shore, gazing into the distance, towards the Moon, the luminary of the night. The returning sailing-boats and the companionship of the three watchers on the shore communicate a sense of security, while the moonlit sky and the limitless expanse of the sea evoke the immensity of the universe.

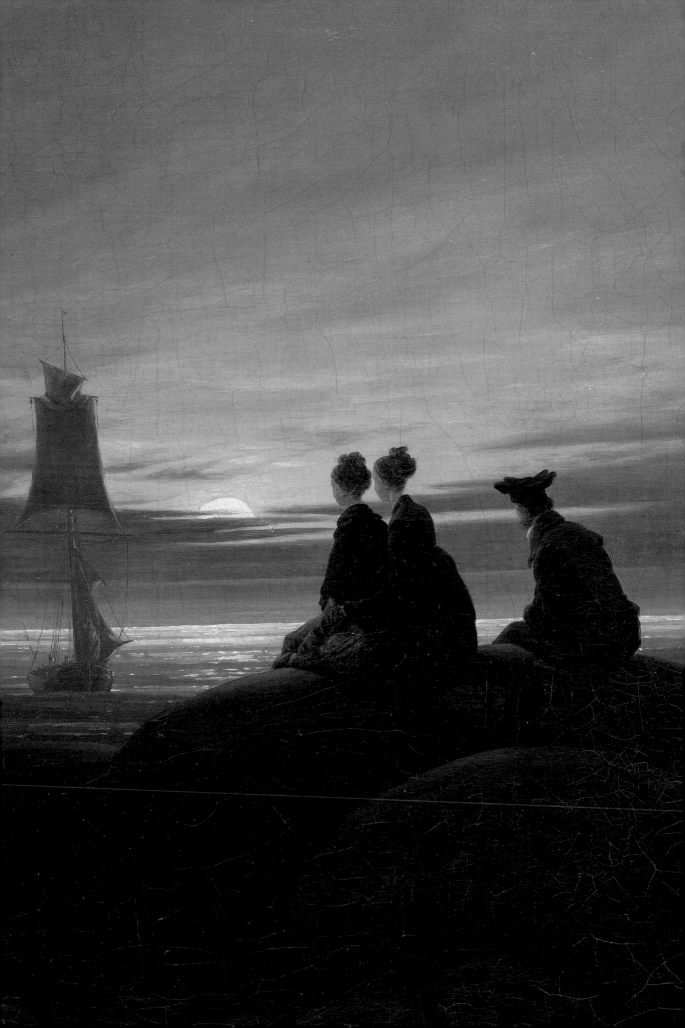

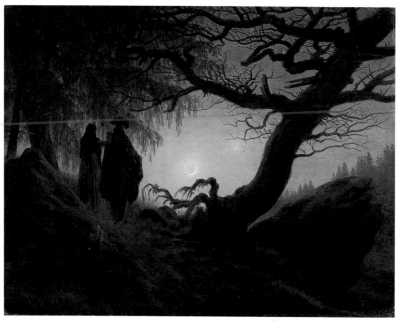

28

29

28
Caspar David Friedrich
1774 Greifswald–1840 Dresden
*Man and Woman Contemplating
the Moon, c.1824*
Oil on canvas, 34 × 44 cm
Purchased in 1936 from Galerie
Nathan, St Gallen

On a hill, beside an uprooted oak
tree, a couple have paused in their
night-time stroll through the
forest, and are gazing at the bright,
comforting moon. Drawn together
in the solemn silence of the night,
the two find themselves faced with
the unfathomable secret of the
universe. Contemporaries assumed
that the painter had here portrayed
himself and his young wife,
Caroline. A first version of this
picture was painted in 1819,
entitled *Two Men Contemplating the
Moon* (Dresden, Gemäldegalerie
Neue Meister).

29
Caspar David Friedrich
1774 Greifswald–1840 Dresden
*The Riesengebirge Mountains,
c.1830–35*
Oil on canvas, 72 × 102 cm
Purchased in 1909 from Frau Elsa
von Corswandt, Berlin

On a hike through the Riesenge-
birge mountains with his friend
Kerstin in 1810, Friedrich had
drawn the view from the Ziegen-
rücken to the Jeschken, the highest
mountain of Northern Bohemia,
and he was able to go back to the
drawing when he painted this
isolated and unspoilt mountain
landscape more than 20 years later.
Evening mist rises from the depths
of the valleys; the materiality
of the distant summit seems to
dissolve into light grey; above is
the lustrous gold infinity of the
evening sky. In the foreground,
hardly distinguishable from the
nature around him, a walker rests
on the hillside.

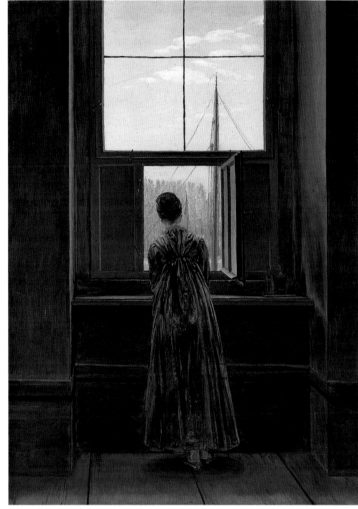

30

30
Caspar David Friedrich
1774 Greifswald–1840 Dresden
Woman at a Window, 1822
Oil on canvas, 44 × 37 cm
Purchased in 1906 from the
painter's family, Greifswald

It was four years into his marriage
that Caspar David Friedrich pro-
duced this small painting in which
his wife, Caroline, appears. With
her back to the viewer, she is
looking out of the window of her
husband's studio towards the far
bank of the Elbe. In this view
through a window, Friedrich was
taking up a profoundly Romantic
motif that combines inner and
outer, closeness and distance, to
express yearning for the infinite.
Together with more than 30 of
his other paintings, *Woman at a
Window* was included in the great
Nationalgalerie exhibition of 1906,
bringing about the rediscovery of
a painter by then forgotten.

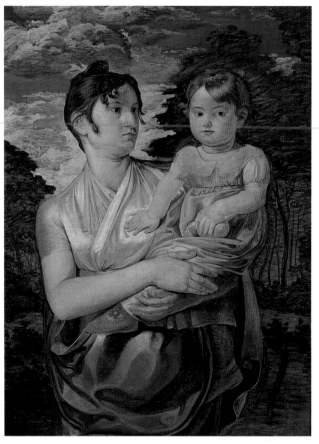

31

31

Philipp Otto Runge
1777 Wolgast–1810 Hamburg
The Artist's Wife and their Young Son,
1807
Oil on canvas, 97 × 73 cm
Gift of Frau Felicie Runge, Berlin,
1932

Married to Pauline Bassenge in
1804, Runge has here painted his
wife with their two-year-old son,
Otto Sigismund, in her arms. Like
the large painting of his parents a
year earlier (now in the Hamburger
Kunsthalle), this unfinished por-
trait was painted at Wolgast. Runge
was at that time deeply engaged
with Early-German art, and he
drew on Late-Gothic paintings and
sculptures of the Madonna for the
composition. The painting, found
rolled up in the attic of one of
Runge's great-grandchildren, was
donated to the Nationalgalerie in
1932 by Frau Felicie Runge.

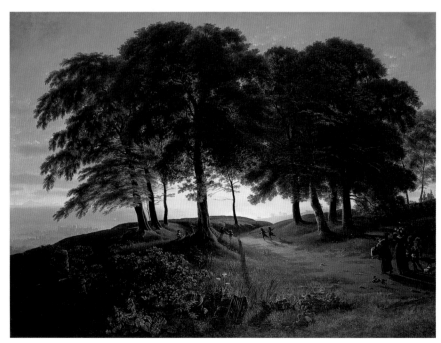

32

32

Karl Friedrich Schinkel
1781 Neuruppin–1841 Berlin
Morning, 1813
Oil on canvas, 76 × 102 cm
Gift of Bruno Cassirer, Berlin, 1911;
once the property of Field Marshal
von Gneisenau

This was painted in 1813 to a
commission by the Prussian field
marshal August, Count Neidhardt
von Gneisenau. In the morning
sunlight, two women in splendid
Renaissance costume are strolling
towards a beech grove. As children
play under the magnificent, mature
trees, two riders appear on the sky-
line to the right. Painted during the
German War of Liberation against
Napoleon, this 'historical' land-
scape – with its reference to the
Renaissance as one of the great
ages of the past – conveys
Schinkel's vision of a Germany
renewed.

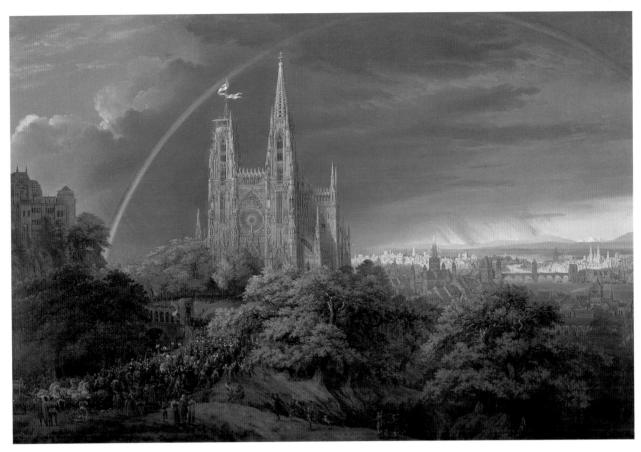

33

33
Karl Friedrich Schinkel
1781 Neuruppin–1841 Berlin
Medieval City on a River, 1815
Oil on canvas, 94 × 140 cm
Held in trust by the Nationalgalerie
since 1914

The sunlit west front of a Gothic cathedral towers against a stormy sky, heavy with rain. The spire of the north tower is unfinished, but a white flag, on which an imperial eagle can be made out, flies from the scaffolding already there. The storm is passing, the first gaps in the clouds allow a glimpse of the blue sky. For German Romantic artists, the Gothic style of architecture, understood as distinctively Germanic, became the glorious symbol of the national unity and strength they longed for. Not far from the Gothic cathedral, a sovereign is making a ceremonial entry into his capital, an allusion, probably, to the victorious return of Friedrich Wilhelm III of Prussia from the Napoleonic Wars.

34
Karl Friedrich Schinkel
1781 Neuruppin–1841 Berlin
A Glimpse of Greece's Golden Age, 1825
(Copy by Wilhelm Ahlborn, 1836)
Oil on canvas, 94 × 235 cm
Purchased in 1954 from Frau
Unruh, Moosrain/Tegernsee

In this picture, the artist expands
upon his idea of a landscape paint-
ing in which nature and human
activity are seen in harmony:
against the background of an ideal
Greek cityscape, naked heroes are
building an Ionic temple. For
Schinkel, the construction of a
temple was the crowning embodi-
ment of an ordered community
and the symbol of a reformed
world order. The original painting
– a wedding gift from the city
of Berlin to the king's youngest
daughter, Princess Luise – has
been missing since the Second
World War.

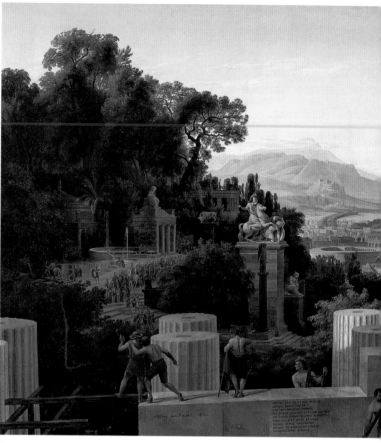

34

35
Georg Friedrich Kersting
1785 Güstrow–1847 Meissen
*Theodor Körner, Friedrich Friesen and
Heinrich Hartmann on Picket Duty*,
1815
Oil on canvas, 46 × 35 cm
Purchased in 1921 from Margarete
Graf-Baraneck, Berlin

These memorial paintings for three
comrades who died in the War of
Liberation are not only an expres-
sion of Kersting's grief at the loss
of his friends but also a patriotic
profession of faith. In this work,
the three volunteers have taken up
position with their muskets on the
sparsely wooded edge of an oak
forest. They wear the Iron Cross
designed by Schinkel in 1813. While
the oak had been a symbol of hero-
ism since the 18th century, the
black, red and gold uniforms refer
to the national feeling newly awak-
ened in Germany.

36
Georg Friedrich Kersting
1785 Güstrow–1847 Meissen
The Wreath-Binder, 1815
Oil on canvas, 40 × 32 cm
Purchased in 1921 from Margarete
Graf-Baraneck, Berlin

In *The Wreath-Binder*, a pendant to
the first painting, a young woman
dressed all in white, like a bride,
sits on a mossy rock beside a forest
stream, binding wreaths of oak-
leaves. Behind her, the oaks loom
like gravestones; carved in their
bark are the names of Körner,
Friesen and Hartmann.

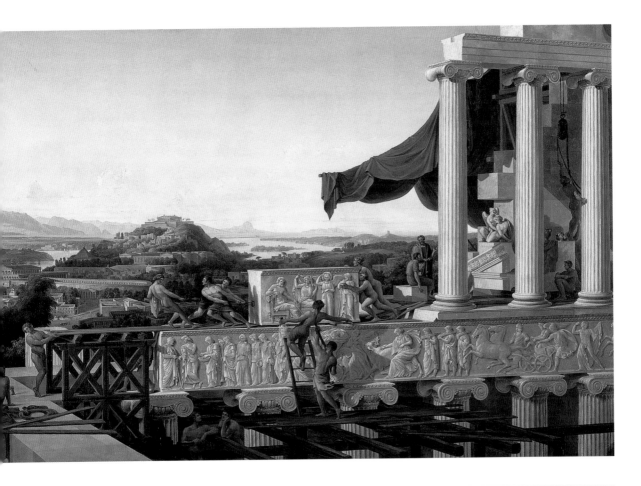

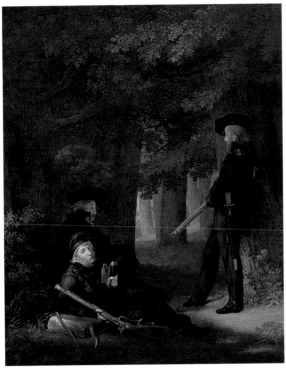

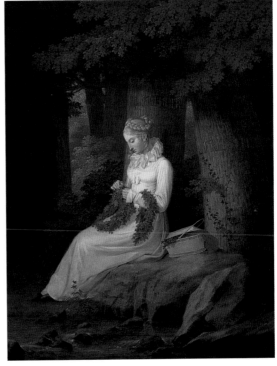

35

36

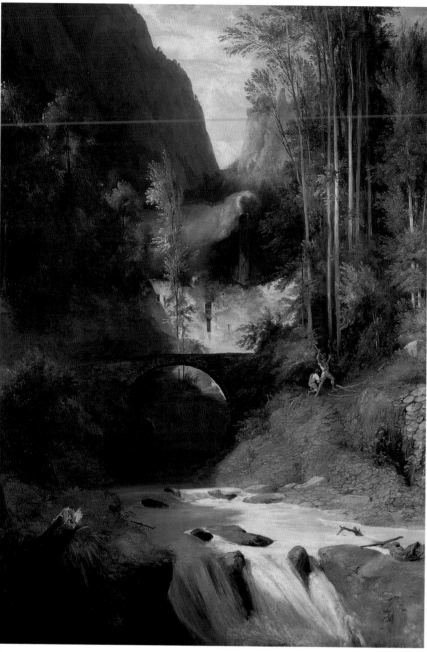

37

Carl Blechen
1798 Cottbus–1840 Berlin
Gorge near Amalfi, 1831
Oil on canvas, 110.3 × 77.5 cm
Purchased in 1881, together with six
of the artist's other works, from
Herr Frick, Berlin

In May 1829, during his momen-
tous trip to Italy, Blechen explored
and sketched the rocky Valle dei
Mulini near Amalfi, with its many
bridges and buildings. Two years
later he painted this piece. Glowing
cliffs emerge from the vegetation
of the deep gorge. Bright sunlight
penetrates the valley, illuminating
the mill walls and turning the
smoke of the chimney to silver.
Woodcutters chop down trees
for fuel. Despite the painterly
integration of the factory into the
serene mountain landscape of
Southern Italy, Blechen's subject
here is indeed the beginning of
industrialisation.

38
Carl Blechen
1798 Cottbus–1840 Berlin
Mountain Gorge in Winter, 1825
Oil on canvas, 98 × 127 cm
Purchased in 1898 with funds from
the Rohr Endowment

As a scene-painter at the
Königstädtischen Theater, Blechen
would have been familiar with
Weber's *Der Freischütz*, and the
Wolf's Gorge scene from this
popular Romantic opera may
have inspired his dark, dramatic
painting of an icy mountain gorge
by night. Hardly perceptible, the
windows of a hut glow in the
distance, but the path is blocked
by the ghostly skeleton of a dead
tree. The light of the mountain
hut barely offers a sign of hope
any more than does the statue of
the Virgin Mary at the foot of
the gorge.

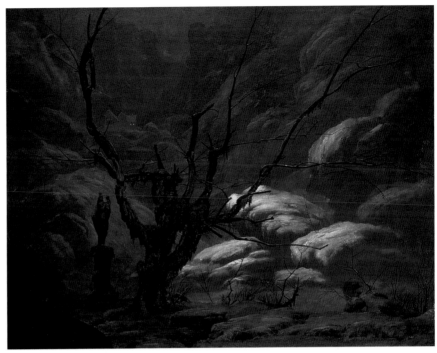

38

39
Carl Blechen
1798 Cottbus–1840 Berlin
The Palm House on the Pfaueninsel,
1832/33
Oil on paper laid on canvas,
64 × 56 cm
Bought at auction in 1898, from
the Karl Ludwig Kuhtz Collection

Having bought the Foulchiron
Palm Collection in Paris on
Alexander von Humboldt's advice,
King Friedrich Wilhelm III had
a Palm House built on Peacock
Island (Pfaueninsel) near Potsdam,
from plans by Karl Friedrich
Schinkel. This incorporated parts
of an Indian pagoda. After work
was completed in 1831, the king
commissioned two paintings of the
new building from Carl Blechen,
to give to his daughter, Charlotte.
As well as numerous drawings,
Blechen also produced the
colour study here. In the sunny
glasshouse, odalisques recline
beneath luxurious tropical
greenery. The filigree detail of the
Indian elements reinforces the
sense of Oriental magic.

39

40

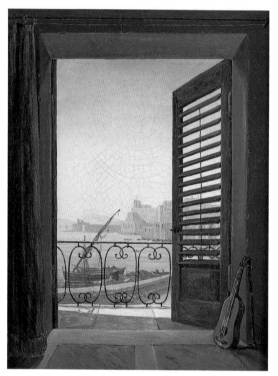

41

40
Ernst Ferdinand Oehme
1797–1855 Dresden
Burg Scharfenberg by Night, 1827
Oil on canvas, 59.5 × 83 cm
Purchased in 1923 from the Galerie
Caspari, Munich

The medieval castle of Scharfenberg had burnt down after being struck by lightning in 1783, and it remained uninhabited until the art lover Carl Borromäus restored the ruin in 1812. He then made it his home, inviting friends such as August Apel, Moritz Retzsch and Friedrich de la Motte Fouqué, and for some years it acted as the centre of the Romantic movement in Saxony. Oehme shows a moonlit scene, with a rider galloping through the stormy night towards the festively illuminated castle, which stands on a rocky outcrop high above the gleaming river.

41
Carl Gustav Carus
1789 Leipzig–1869 Dresden
Balcony overlooking the Bay of Naples,
*c.*1829/30
Oil on canvas, 28.4 × 21.3 cm
Purchased in 1992 by the Friends of the Nationalgalerie, from Kunstkabinett Werner Kittel, Hamburg

Using pale, luminous colours, the doctor, natural scientist, philosopher and artist Carl Gustav Carus offers us a view from his quarters in the Casino Reale in Naples. A golden afternoon light falls on the harbour and the island of Capri shimmers on the horizon. Silence reigns in the shady interior, but the guitar leaning against the wall hints at the singing of the fishermen, which echoes through the port at night. In this view through a window, Carus engages with a standard Romantic metaphor for human yearning: another world opens up beyond the palpable, materiality of the foreground.

42

John Constable
1776 East Bergholt, Suffolk–1837
London
The Grove, or the Admiral's House,
Hampstead, 1821/22
Oil on canvas, 60 × 50 cm
Gift of Paul, Freiherr von Merling,
Berlin, 1901

From 1819, Constable regularly
spent his summer months in
Hampstead, London, where he
produced numerous landscapes
and cloud studies. This is a view of
'The Grove,' the home of Admiral
Matthew Barton, as seen from
Constable's rented house. On a
stormy summer's day, the building
glows among the dark, wet foliage
of the trees surrounding it.
Constable's approach to nature
made him the pioneer of a modern
realism that was concerned with
mood and light.

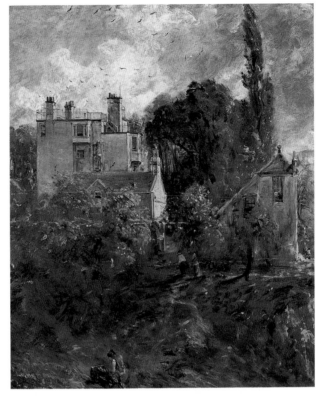

42

43

Carl Rottmann
1797 Handschuhsheim/Heidel-
berg–1850 Munich
*The Battlefield of Marathon, c.*1849
Oil on canvas, 91 × 90.5 cm
Purchased in 1875 through
Kunsthandlung Miethke, Vienna

Rottmann produced this visionary
painting of the battlefield of
Marathon a year after completing
his mural paintings on the same
subject for the arcades of Munich's
Hofgarten. However, the historic
battle in which the Greeks won a
decisive victory over the Persians
in 490 BC is nowhere to be seen.
Rottman has projected the action
into the cosmic realm, making it a
battle of the elements, a struggle
between light and darkness.

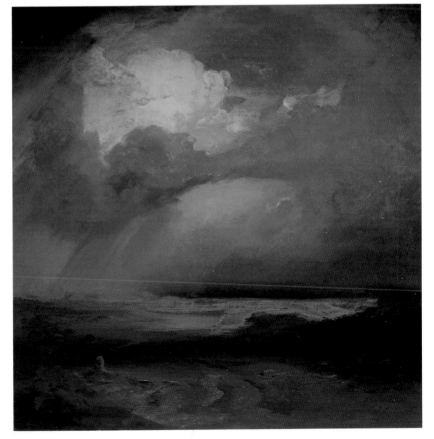

43

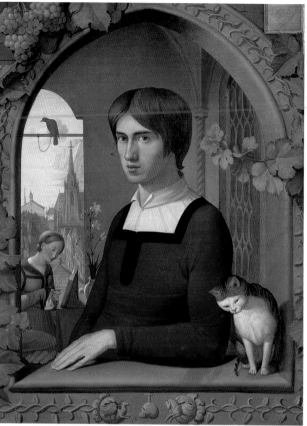

44

44

Friedrich Overbeck
1789 Lübeck–1869 Rome
Portrait of the Painter Franz Pforr,
1810
Oil on canvas, 62 × 47 cm
Purchased in 1887 from the painter
Carl Hoffmann

After meeting in 1806 at the
Vienna Academy, Friedrich
Overbeck and Franz Pforr enjoyed
an intimate friendship. Overbeck's
portrait was intended to capture
his friend, caught in a moment
of utter happiness. It was inspired
by Pforr's report of a dream in
which he saw himself as a history
painter, surrounded by old master
paintings and enraptured by the
presence of a beautiful woman.
Overbeck paints Pforr in 'old
German' costume, looking out
through a Gothic window enlaced
in vines. The view onto a late-
medieval German town with a
sunlit Italian coastal landscape
beyond, evoked the Nazarene
conception of the affinity between
German and Italian art.

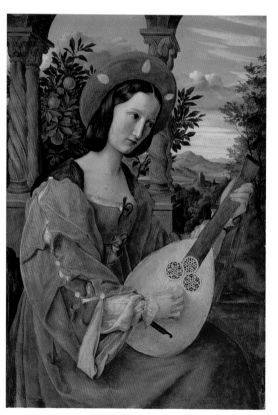

45

45

Julius Schnorr von Carolsfeld
1794 Leipzig–1872 Dresden
Portrait of Clara Bianca von Quandt,
1820
Oil on wood, 37 × 26 cm
Purchased in 1922 from Galerie
Heinemann, Munich

On their honeymoon, the Leipzig
merchant and art collector Johann
Gottlob von Quandt and his wife
Clara Bianca spent some time in
Rome. They were close friends
of the painter Julius Schnorr.
The portrait shows a lute-playing
woman in Italian Renaissance
dress seated before a medieval
arcade. At Quandt's request, it is
based on a painting then ascribed
to Raphael himself, which depicted
Joan of Aragon (then in the Palazzo
Doria Pamphili and now in the
Louvre).

46

Friedrich Overbeck

1789 Lübeck–1869 Rome

Joseph Sold by his Brothers, 1817

Mural from the Casa Bartholdy in
Rome

Fresco overpainted in tempera,
244 × 298 cm

Acquired 1887/88

47

Peter Cornelius

1783 Düsseldorf–1867 Berlin

Joseph Interprets Pharaoh's Dream,
1816/17

Mural from the Casa Bartholdy in
Rome

Fresco overpainted in tempera,
246 × 331 cm

Acquired 1887/88

Young German artists in Rome
founded the Brotherhood of
St Luke in order to realise the
Romantic dream of collaborative
work for the renewal of art. Model-
ling their clear, expressive style
on that of the Early Renaissance
masters, the fraternity hoped for
an art that would be both Christian
and distinctively German. They
gained their first commission for a
fresco in 1816, from Jacob Salomon
Bartholdy, the Prussian Consul-
General. He had the banqueting
hall of his home in the Palazzo
Zuccari decorated with scenes
from the Old Testament story
of Joseph, which were painted
by Peter Cornelius, Wilhelm
Schadow, Philipp Veit and
Friedrich Overbeck.

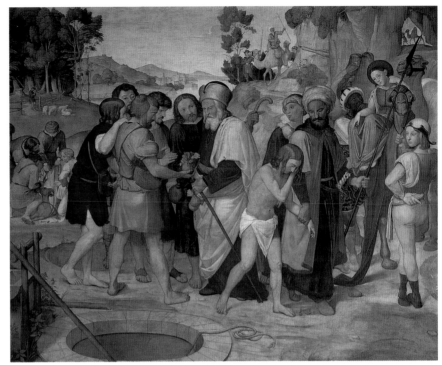

46

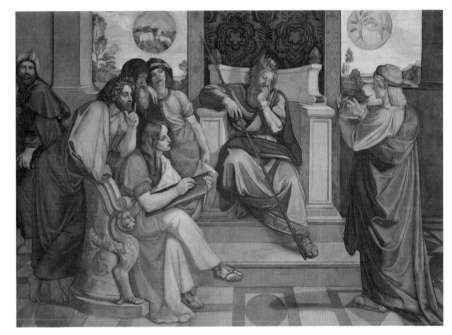

47

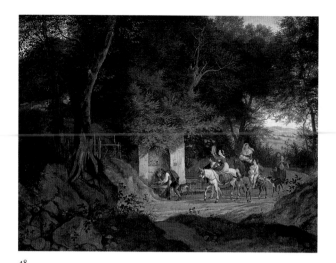

48

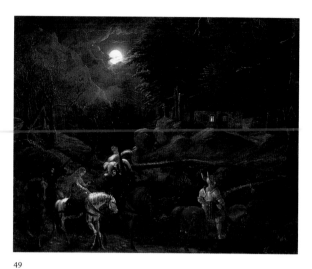

49

48
Adrian Ludwig Richter
1803–1884 Dresden
Woodland Spring near Ariccia, 1831
Oil on canvas, 47 × 61 cm
Bequeathed by G. A. Freund,
Berlin, 1914

While he was a teacher of drawing
at the Meissen porcelain manufac-
tory, Ludwig Richter repeatedly
painted his impressions of travel
in Italy, memories imbued with a
transfiguring nostalgia. Richter
based this painted recollection on
several sketches made in the area
around Ariccia. Typical figures of
the Italian countryside appear as
if on stage: a hunter and his dog,
a tambourine player on her horse
and a mother with her children,
with a mendicant friar behind.

49
Carl Philipp Fohr
1795 Heidelberg–1818 Rome
*Knights before the Charcoal-Burner's
Hut*, 1816
Oil on canvas, 54 × 66 cm
Purchased in 1931 from Herr
Reichart, Innsbruck

This picture is based on Friedrich
de la Motte Fouqué's novel of
chivalry, *The Magic Ring*, published
in 1813. It shows an episode from
the 12th chapter of Part III of
the book, in which Otto von
Trautwangen and his mother,
accompanied by Arinbiörn and
Heerdegen von Lichtenried, seek
shelter for the night at a charcoal-
burner's hut. Faithful to his text,
Fohr has rendered the scene as a
painterly nocturne. The broken,
wooded landscape lies silent and
lonely; bathed in moonlight, the
knights' armour gleams silver or
glows mysteriously in gold.

50
Moritz von Schwind
1804 Vienna–1871 Munich
The Rose, or The Artist's Journey,
1846/47
Oil on canvas, 216 × 134 cm
Purchased in 1874 from Herr
Schwartz, Erlangen

Atop a castle tower, a bride and her
ladies-in-waiting attend the arrival
of her groom, who can be seen in
the distance with his retinue.
Coming from the other direction,
musicians are arduously climbing a
narrow path. This is the encounter
of two social spheres, the ideal
world of fairy-tale knighthood
and the grotesque reality of the
artist as outsider. 'The hero,' wrote
Schwind, 'is the last of the musi-
cians, a man of high ideals,' but
'a genius gone to ruin.'

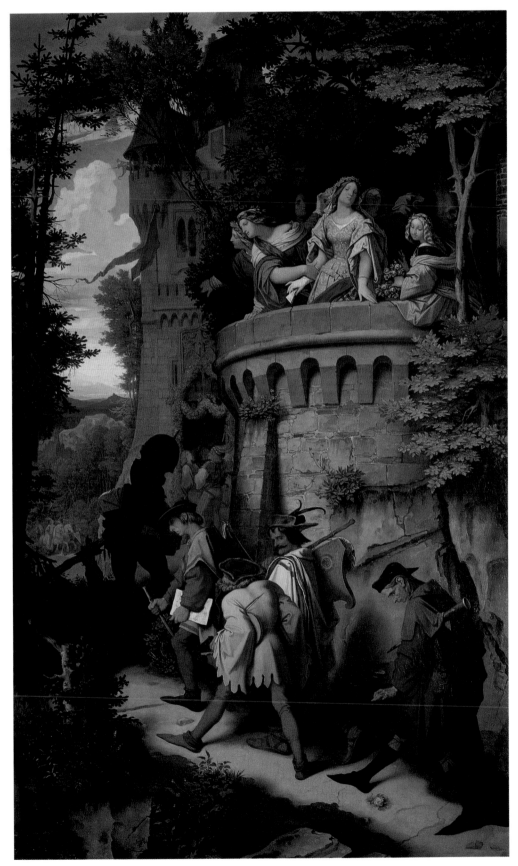

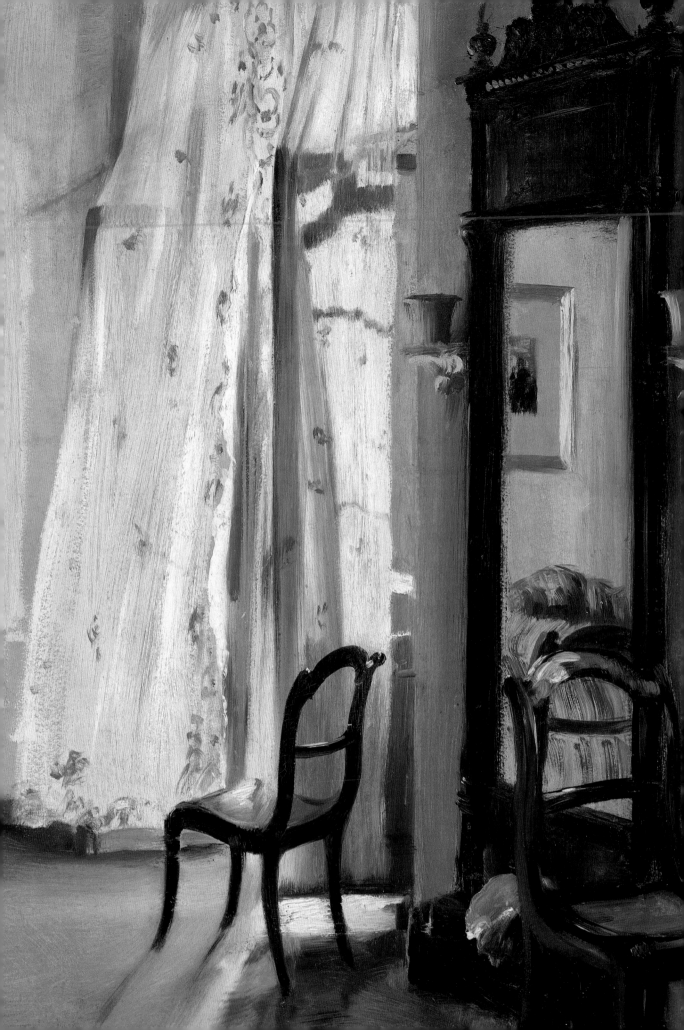

Biedermeier and Early Realism

Biedermeier is the neoclassically imbued style that characterises the painting, the graphic arts and especially the design of the German-speaking countries, from the victory over Napoleon in 1815 to the Revolution of 1848. The Biedermeier style takes its name from Ludwig Eichrodt's verse parody, *The Story of Swabian Schoolmaster Gottlieb Biedermeier*, published between 1850 and 1857 in Munich's *Fliegende Blätter*. The schoolmaster of the title came to stand for the prototypical petit-bourgeois, a figure of fun embodying the next generation's view of the supposedly worthy and stolid period that followed after the War of Liberation.

Biedermeier painting combined the Romantics' interiorised conception of art with the new, more acute vision of *things*. Architecture and design were simplified and given greater structural clarity compared to the old Empire style, but the change in painting was less in form than in content. The favoured genre was landscape and its related urban view. Second in importance was the portrait; instead of documenting social status and traditional patterns of conduct, painters now took pains to depict character, sensitively and impartially. The numerous interiors and friendship paintings mirror the retreat into the domestic and an involvement with the narrow circle of friends and family that was characteristic of the period.

The most important Berlin portrait-painter was Franz Krüger, who painted princes and courtiers with the same factual impartiality as he did his bourgeois contemporaries. Krüger's official work is represented by not only his formal *Prince August von Preußen of Prussia* but also his 'Parade Paintings', in which the focus on those watching the events presents the streetscape as a stage for middle-class self-presentation. If, for Krüger, architecture provided an impressive backdrop, for the younger Eduard Gaertner it became the sole subject matter. Trained by the decorator and scene-painter Karl Wilhelm Gropius, he developed a new genre of architectural painting characterised by exact observation and a highly differentiated rendering of light, livening up his urban views with subtle light-effects and a limited but effective use of staffage figures. Only at first glance, on the other hand, do Johann Erdmann Hummel's views of the city give the impression of photographic precision. In his maturity, having become professor of architecture, perspective and optics at the Akademie, Hummel developed an interest in the skilful rendering of light-effects and of complex reflected images, of which the *The Granite Bowl at the Lustgarten, Berlin* is a most impressive example.

The most important representative of Biedermeier painting in Munich was Wilhelm von Kobell. He trained at the Mannheimer Akademie, which was influenced by Dutch seventeenth-

century painting, and specialised in animal and battle paintings, receiving his first commission from Karl Theodor, Elector of Bavaria, in 1792. He later developed a new, highly successful form of the hunting picture, whose unchanging composition – a broad, open landscape with a stage-like surface in the foreground – provided him with a suitable setting for the gathered company of aristocratic huntsmen.

A decisive step towards a new conception of portraiture was taken by one of the most important of the Viennese Biedermeier painters, Ferdinand Georg Waldmüller. He was a master in the depiction of fabrics, whether silk, muslin, velvet or lace; of elegant hair styles and jewellery; the charm and beauty of young women; masculine maturity; and of dignified old age. Like Jean-Auguste-Dominique Ingres, to whom he may be compared in the linearity of his style, Waldmüller, for all the virtuosity of his painting, had a real empathy with his subjects. This focus on individuality is also present in his narrative figure-paintings, distinguished not only by their precise imitation of nature but often by their sophisticated handling of light.

When, in 1826, the Berlin painter Wilhelm Schadow was appointed director of the Royal Prussian Academy of Arts in Düsseldorf, taking with him his best pupils – Theodor Hildebrandt, Julius Hübner, Carl Friedrich Lessing and Carl Ferdinand Sohn – it marked the beginning of an ever-closer relationship between the Prussian capital and this up-and-coming Rhineland city. The Düsseldorf School of Painting, established by Schadow and his friends, favoured historical subjects, rendered in an idealising, draughtsman-like, linear style. Alongside the history painting and the landscape art to whose revival Lessing in particular made an important contribution, its members also painted portraits, represented in the Nationalgalerie by outstanding works by Hübner and Alfred Rethel.

However, the most important German painter of the nineteenth century was Adolph Menzel, and not only on account of his versatility. His early engagement with Prussian history – producing almost 400 illustrations for Franz Kugler's *History of Frederick the Great* – led him in the 1850s to take up history painting. Initially retaining Frederick as a subject, he later moved on to more contemporary subjects from Prussia's recent history, as exemplified in paintings such as the famous *Flute Concert of Frederick the Great at Sanssouci*. Alongside this, since the 1840s, he had been interested in subjects from everyday life, depicted in small-format oil paintings, pastels and a large number of drawings. In these Menzel shows evidence not only of acute observation but also of a surprising and often poetic eye. This can be seen in the famous *Balcony Room*, only superficially a representation of a peaceful summer's day, and in the *Plaster Casts on the Studio Wall*, a sophisticated study of light and a testimony to the fragility of life.

Nicole Hartje

51
Johann Erdmann Hummel
1769 Kassel–1852 Berlin
The Chess Game, 1818/19
Oil on canvas, 38.5 × 44 cm
Purchased in 1904 from Prof. Fritz
Hummel, Berlin

This scene is a room in the Palais
Voss in Berlin's Wilhelmstraße,
where Count Ingenheim's friends
regularly meet for a game of chess.
Commissioned by the Dutch queen
Wilhelmina, this picture of a group
of chess lovers turns out to be a
society painting, with the architect
Hans Christian Genelli smoking a
clay pipe, the archaeologist Alois
Hirt next to him, seated in the
middle (in front of the window)
their host Count Gustav Adolf von
Ingenheim, the painter Friedrich
Bury to his right, and at the front
the Queen's brother, Count
Friedrich Willhelm von Branden-
burg. At the window, in the back-
ground, is the artist himself. The
different light sources – from the
lamp, candles and moon – produce
a complex play of light and shade
that is echoed in the mirror.

52
Johann Peter Hasenclever
1810 Remscheid–1853 Düsseldorf
Ferdinand Freiligrath, 1851
Oil on canvas, 65.5 × 55.3 cm
Gift of the poet's widow, Frau Ida
Freiligrath, 1890

Hasenclever painted this portrait
of Ferdinand Freiligrath – the poet
and revolutionary democrat who
was Karl Marx's co-editor on the
Neue Rheinische Zeitun – at a time
when his position had taken a
dramatic turn for the worse, for in
May 1851 he was forced to flee to
England for a second time.

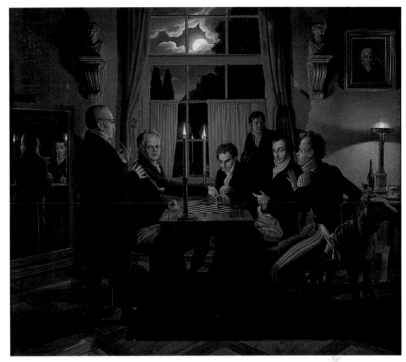

51

52

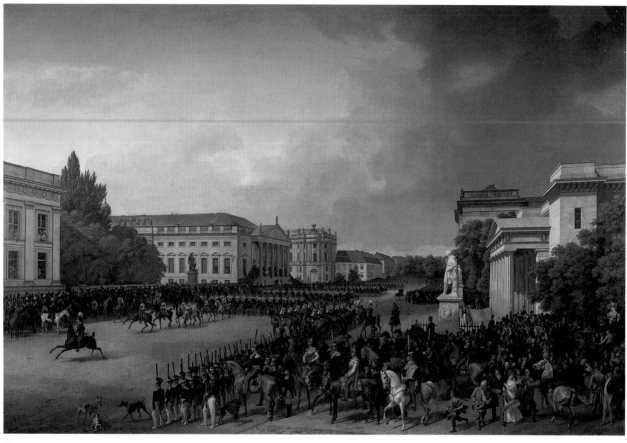

53

53
Franz Krüger
1797 Großbadegast/Anhalt-Dessau –
1857 Berlin
Parade on Opernplatz in 1822,
1824–30
Oil on canvas, 249 × 374 cm
Acquired in 1928 after agreement
with the former Prussian royal
house

It was for Czar Nicholas I that Krüger painted this acutely observed panorama of Berlin society. Rejecting conventional principles of composition, he has placed the Czar (at the head of his troops) and King Friedrich Wilhelm III to one side, so that the Berliners on the square between the Armoury and Schinkel's New Guardhouse find themselves being the centre of attention. Among them are such prominent figures as the sculptors Rauch and Schadow, the architect Schinkel, Henriette Sonntag (the famous singer) and the violonist Paganini, as well as representatives of the ordinary Berlin citizenry, a young cobbler to the fore.

54
Johann Erdmann Hummel
1769 Kassel–1852 Berlin
The Granite Bowl at the Lustgarten,
Berlin, 1831
Oil on canvas, 66 × 89 cm
Gift of Herr L. Bialon, Berlin, 1905

Inspired by an English example,
King Friedrich Wilhelm III had a
huge bowl made from a solid block
of granite, bigger even than the
antique porphyry bowl from
Nero's Golden House in Rome.
This painting is one of a series of
three, showing the cutting and
turning of the stone and the even-
tual installation of the bowl in the
Lustgarten, in front of the Altes
Museum. For Hummel, the subject
offered the opportunity for a
demonstration of optical phenom-
ena. So the main emphasis falls on
the bowl's mirroring of the figures
nearby, who make a second
appearance in a panorama-like
circular image, upside down.

55
Franz Krüger
1797 Großbadegast/Anhalt-
Dessau–1857 Berlin
Prince August von Preußen of Prussia,
c.1817
Oil on canvas, 63 × 47 cm
Purchased in 1890 from the estate
of Mathilde von Waldenburg,
Berlin

Prince August of Prussia, nephew
of Frederick the Great, posed for
this portrait in the just-completed
reception hall of the Prinzenpalais
in the Wilhelmstraße. The 'painting
within a painting' is a portrait by
François Gérard of Madame de
Récamier, the wife of a Paris
banker and a much-admired
beauty of the day. The prince had
fallen in love with her at Château
Coppet on Lake Geneva, but his
wish to marry her fell through.

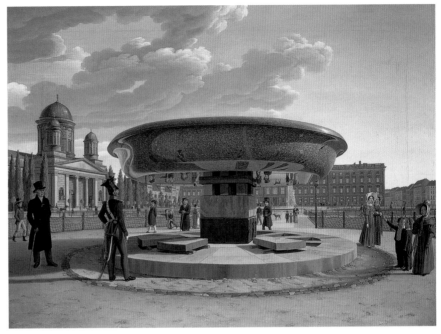

54

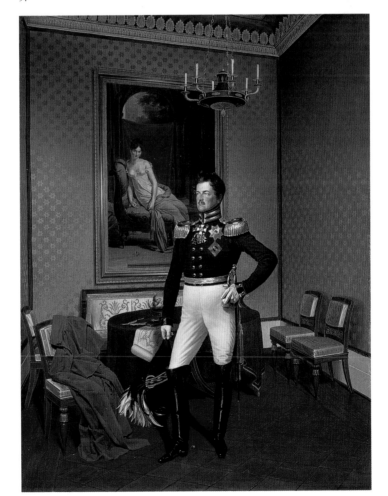

55

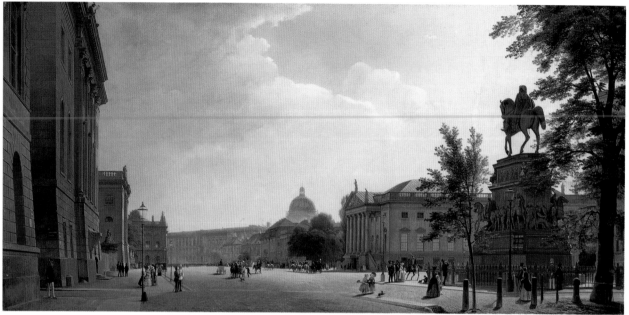

56

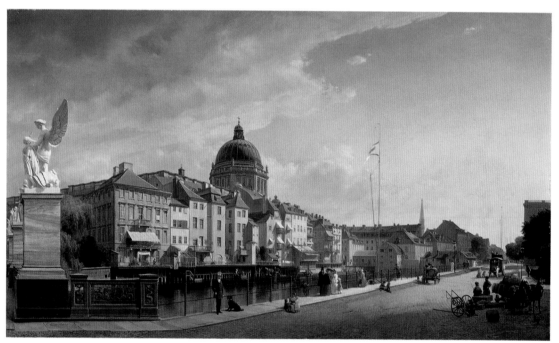

57

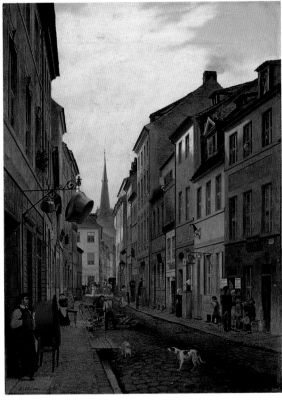

58

56
Eduard Gaertner
1801 Berlin–1877 Flecken Zechlin
Unter den Linden, 1852
Oil on canvas, 75 × 155 cm
Acquired in 1880 from Herr Fritz
Lion, Vienna, in exchange for two
paintings by Joseph Brandt

For this daring composition, sym-
bolic of the Prussian monarchy,
Gaertner has taken up position
just a little back from the end of
the avenue of limes. From the
corner of the Academy building,
one's gaze moves down to the
Stadtschloss, taking in Prince
Heinrich's Palace and the Armoury
on the left, and the Opera House
and the Crown Prince's Palace on
the right. On the right in the fore-
ground is Christian Daniel Rauch's
equestrian statue of Friedrich II.
The king seems to ride towards
the Stadtschloss, dim in the
distance, where one can just make
out a military parade taking place,
executed in an accomplished
miniature technique.

57
Eduard Gaertner
1801 Berlin–1877 Flecken Zechlin
*Rear View of the Houses on the
Schlossfreiheit*, 1855
Oil on canvas, 57 × 96 cm
Property of the Friends of the
Nationalgalerie

The painting shows the view from
the Unterwasserstraße at its corner
with the Schlossbrücke, over the
Spree Canal to the houses on the
Schlossfreiheit, later sacrificed to
imperial perspectives (1895). At the
back of this row of 17th-century
houses, standing at the water's
edge with its planted balconies and
awnings, is an extremely pictur-
esque view. Over this everyday,
middle-class idyll looms the mag-
nificence of the Schloss, in the
form of Stüler's dome.

58
Eduard Gaertner
1801 Berlin–1877 Flecken Zechlin
Parochialstraße, 1831
Oil on canvas, 39 × 29 cm
Acquired in 1861 as part of the
Wagener Bequest

This picture shows the slightly
crooked section of the Parochial-
straße in the historic centre of
Berlin. With its numerous artisans
and tradesmen, the neighbourhood
was one of those areas, typical of
the city, where people both lived
and worked. This view of the
narrow street shows the almost
homely world of the city's
'ordinary people,' sawing wood on
the cobbled street, quenching their
thirst at the inn or offering their
wares for sale, like the coppersmith
on the left.

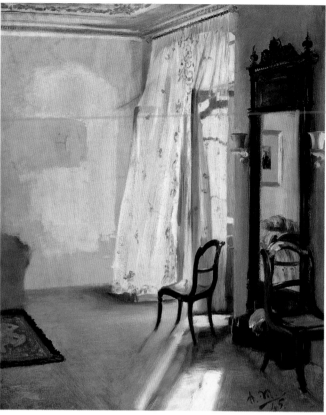

59

59

Adolph Menzel
1815 Breslau–1905 Berlin
The Balcony Room, 1845
Oil on cardboard, 58 × 47 cm
Purchased in 1903 from Hermann
Pächter (Kunsthandlung
R. Wagner), Berlin

Menzel's interest in the trivial
subject, the surprising view and
the transient moment emerges in
his paintings of the 1840s. Often
painted on cardboard, they are
distinguished by their artful
combination of calculation in
composition and liveliness of
representation. While the early
window paintings documented his
view over the roofs of Berlin, here
he is interested in the window
and the room itself. The shaft of
sunlight and the poetic rustle of
the lace curtain find a disquieting
contrast in the distinct emptiness
of the room.

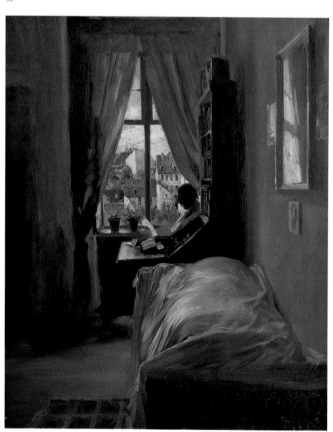

60

60

Adolph Menzel
1815 Breslau–1905 Berlin
*The Artist's Bedroom in the
Ritterstraße*, 1847
Oil on cardboard, 56 × 46 cm
Purchased in 1905 through
Kunsthandlung R. Wagner, Berlin

As a type, the 'window painting'
is associated with the Romantics.
This is one of Menzel's most beau-
tiful 'interior' landscapes, showing
his own bedroom; it represents a
breach with that pictorial tradition
in its reversal of painterly conven-
tions, the view being clear and full
of detail while the interior is
blurred and imprecise. Between
these two zones is the shadowed
profile of a man, whom art histo-
rians suppose to be Menzel's
younger brother, Richard.

61

Adolph Menzel

1815 Breslau–1905 Berlin
Rear Courtyard and House, 1844
Oil on canvas, 44.5 × 61.5 cm
Purchased in 1906 from Salon Fritz
Gurlitt, Berlin

Menzel, the observer, began his
reconnaissance of the visible world
with what was close to hand;
hence his pictures of the view
from the windows of his succes-
sive apartments, and with his
frequent changes of accommoda-
tion this seemingly simple subject
offered ever-new insights. The
view from his second-floor apart-
ment on the Zimmerstraße thus
revealed a panorama in intersect-
ing diagonals, described by the tall
wooden fence, a washing-line and
a water pump with its long runnel.

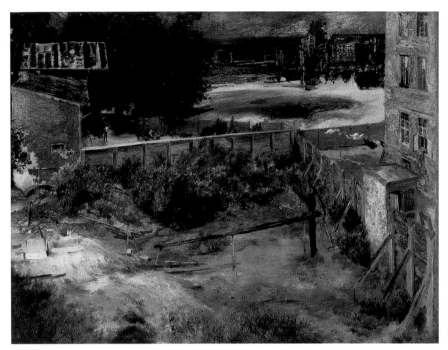

61

62

Adolph Menzel

1815 Breslau–1905 Berlin
Plaster Casts on the Studio Wall, 1852
Oil on paper, laid on wood,
61 × 44 cm
Purchased in 1906 from
Kunsthandlung R. Wagner, Berlin

Menzel used this study of plaster
casts of human limbs on the studio
wall in preparatory work for his
night painting of *Friedrich and his
Family at Hochkirch* (Nationalgal-
erie, missing). The way the casts
are arranged around the missing
trunk and are sparsely lit from a
source outside the picture plane
gives the work the air of a Vanitas
painting, as does the skull and the
dissected hand from whose grasp
the palette appears to have fallen.

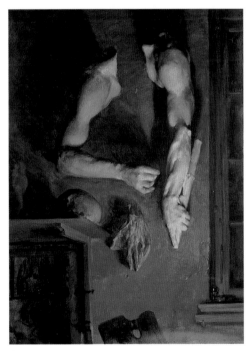

62

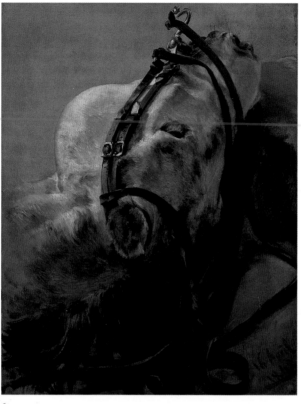

63

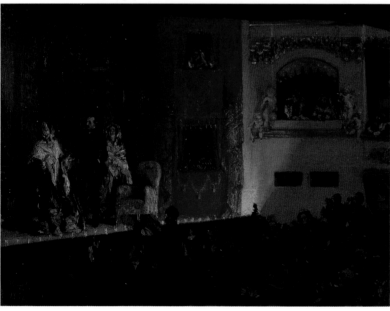

64

63

Adolph Menzel
1815 Breslau–1905 Berlin
Equine Study, Recumbent Head in Harness, 1848
Oil on paper, laid on cardboard,
64.2 × 50 cm
Purchased in 1906 from the artist's estate

When, in April 1848, Menzel had several horses' heads brought to him from an abattoir so that he could paint them, in the studio he was continuing the life studies he had done at a stud farm in Kassel. If at first the focus was on the exact depiction of the object and its materiality, following the experience of uprising and death caused by the 1848 Revolution, it would not be implausible to suggest that the cut-off head was intended as a reference to the bloody events of that time and to the failure of the Revolution.

64

Adolph Menzel
1815 Breslau–1905 Berlin
The Théâtre du Gymnase, 1856
Oil on canvas, 46 × 62 cm
Purchased in 1906 from Herr Adolf Rothermund, Dresden-Blasewitz

During his first visit to Paris in 1855, Menzel went to the Théâtre du Gymnase, popular for its conversation pieces. Done from a contemporaneous sketch, like the *Flute Concert* of four years earlier, this painting also depicts a performance before an audience. Rather than one figure surrounded by attentive and sympathetic listeners, here there are three actors on stage, while beneath them is a crowd of unidentifiable figures, eagerly awaiting the next witticism.

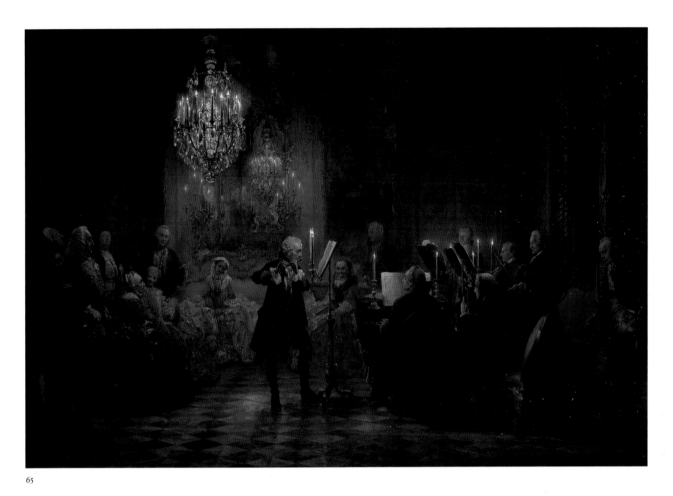

65

65

Adolph Menzel

1815 Breslau–1905 Berlin
*The Flute Concert of Frederick the
Great at Sanssouci*, 1850–52
Oil on canvas, 142 × 205 cm
Purchased in 1875 from Herr
Magnus Herrmann, Berlin

Probably the most popular of
Menzel's paintings, this depicts an
evening concert given by Frederick
the Great in honour of his sister,
the Markgräfin Wilhelmine von
Bayreuth. The location is the
concert hall at Sanssouci, lit by the
atmospheric glow of candles and
chandeliers. Numerous portrait
studies and oil sketches document
the development of this painting
over a number of years. For the
duration of the piece, a mixed
company of family members, close
friends and professional court
musicians finds itself united in
the melody.

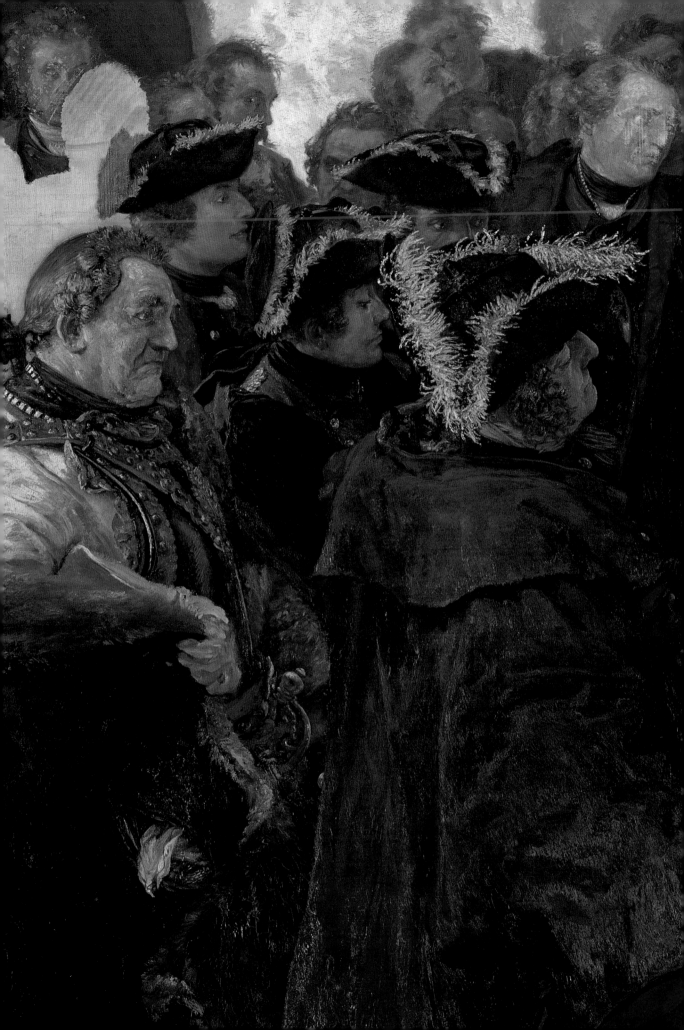

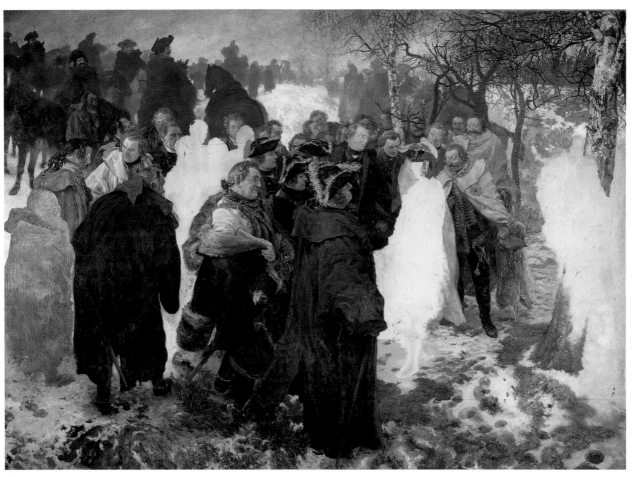

66

66
Adolph Menzel
1815 Breslau–1905 Berlin
Frederick the Great addresses his
Generals before the Battle of Leuthen,
1859–61
Oil on canvas, 318 × 424 cm
Transferred to the Nationalgalerie
in 1934; previously the property of
Wilhelm II, to whom it had been
presented by Menzel's heirs in 1905

This is the last of a series of 11
paintings of Friedrich II, begun
in 1849. At Leuthen, during the
second year of the Seven Years
War, the King, faced by the
Austrians' great superiority, called
on his generals to carry the fight
to the enemy with an unflinching
determination. As opposed to the
tendency of the time to glorify his-
torical events, what is important to
Menzel here is characterisation, the
generals' reaction to this hazardous
enterprise. On their faces we see
not subordination and unquestion-
ing obedience but doubt and
strained concentration. The
cavalier perspective and the
provocative arrangement of the
figures, which shifted the focus of
attention away from the King,
meant that the painting found no
buyer, and it remained unfinished.

67

67

Adolph Menzel

1815 Breslau–1905 Berlin
The Berlin–Potsdam Railway, 1847
Oil on canvas, 42 × 52 cm
Purchased in 1899 from Hermann
Pächter (Kunsthandlung
R. Wagner), Berlin

The long curve of the Berlin–
Potsdam railway cuts through the
uncultivated land outside the gates
of Berlin. Menzel was the first
to discover this as a worthwhile
subject for painting. He is reputed
to have increasingly abandoned a
vision of the world as a totality in
order to confront the viewer with
fragments, an observation equally
true of his landscapes such as this.

68

68

Adolph Menzel

1815 Breslau–1905 Berlin
Building Site with Meadow, 1846
Oil on paper, laid on cardboard,
25 × 40 cm
Purchased in 1905 from Julius Auf-
sesser, a notable Berlin collector

Building Site with Meadow shows
an area on the Schafgraben, the
present-day Landwehrkanal. What
appealed to Menzel at this other-
wise insignificant spot were the
contrasts between the clear struc-
ture of the architecture and the
unruly growth of nature, the
diffuse half-shadow of the bank
and the brightness of the building
site. The way the sun drenches the
background in gleaming light while
only breaking through the trees in
parts, and Menzel's skill in express-
ing this in his colour and brush-
work – these had no parallel in
Germany at that time.

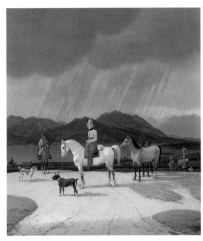

69

70

69

Wilhelm von Kobell
1766 Mannheim –1853 Munich
Riders at the Tegernsee, 1832
Oil on wood, 27 × 25 cm
Purchased in 1928 from Galerie
Caspari, Munich

This small panel painting is an
example of the 'encounter picture'
that Kobell developed from 1815
onwards, inspired by Dutch
models. United in enigmatic still-
ness, the *Riders at the Tegernsee*
are drawn up in a semicircle on
a sunny hilltop, which offers an
extensive view over the landscape.
The figures stand out from the
dark background like cut-outs,
seeming not powerful but almost
rather dainty. Kobell's light colours
and glaze-like application of the
paint give the picture an atmos-
pheric transparency and an air
of serenity.

70

Ferdinand Georg Waldmüller
1793 Vienna–1865
Hinterbrühl/Vienna
Prater Landscape, 1830(?)
Oil on wood, 71 × 91.5 cm
Purchased in 1905 from Kunst-
handlung H. O. Miethke, Vienna;
missing 1945–99, recovered 2000

Having concentrated on subjects
in close-up for a long time, from
the early 1830s Waldmüller began
to focus, above all, on the contrast
between the very near and the
distant. Painted from an exception-
ally low point of view, the *Prater
Landscape* shows the elm trees'
mass of foliage almost overpower-
ingly close, while the apartment
houses of the new Leopoldstadt on
the horizon seem very far away
indeed. Waldmüller loved the
morning light, which casts long
shadows and falls almost horizon-
tally on the trunks of the trees,
glowing pale on their barkless
patches. One small staffage figure
enlivens the landscape and offers a
clue to the massive size of the
ancient trees.

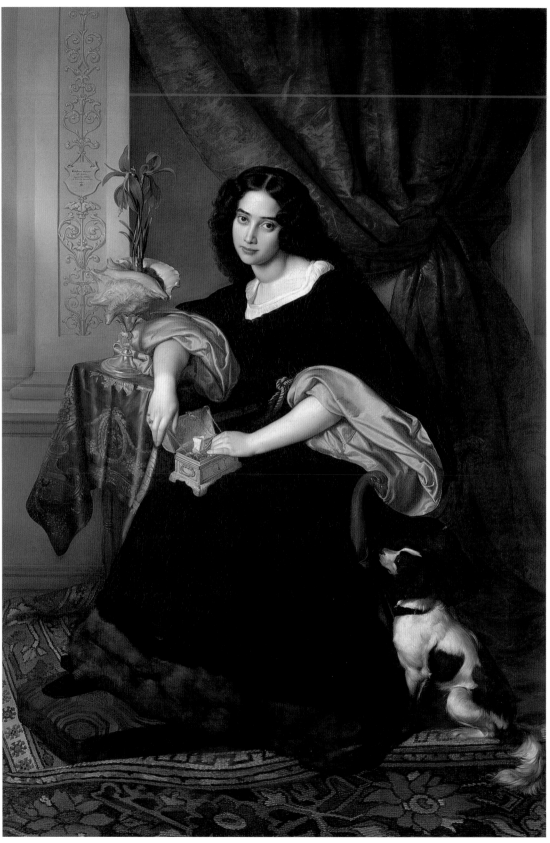

72

71
Julius Hübner
1806 Oels–1882 Loschwitz
Pauline Charlotte Bendemann, 1829
Oil on canvas, 189.5 × 130 cm
Inscription, left of centre:
Carissimam coniugem aet. 19 ann.
depinxit Jul. Hübner amoris sui
monumentum 1829 JH
Purchased in 1923 from Heinrich
Hübner, Berlin

Julius Hübner painted this large
portrait of his fiancée, Pauline
Bendemann, in the year that he
married her. He had met her at a
drawing class, together with her
brother, his painter friend Eduard
Bendemann. The magnificence of
setting and costume, with Pauline
in her fur-trimmed dress, and
heavy crimson drapery behind,
with her dog gazing faithfully up
at her, gives this picture of a young
19-year-old woman the air of a
royal portrait. The convoluted
form of the nautilus shell, with a
red lily growing from it, adds an
erotic note.

72
Julius Hübner
1806 Oels–1882 Loschwitz
Portrait of the Painters Carl Friedrich
Lessing, Carl Sohn and Theodor
Hildebrandt, 1839
Oil on canvas, 38.5 × 58.5 cm
Inscribed under the respective
portraits: *Carl Friedr. Lessing aus*
Wartenberg; Carl Sohn aus Berlin;
Theodor Hildebrandt aus Stettin
Purchased in 1906 from a private
owner in Dresden

Hübner has here departed from the
conventions of the then-traditional
'friendship picture' as understood
by the Romantics, with the linear-
ity of the style and the severity of
the profile view recalling Early
German painting. The composition
of the group – with Lessing caught
active, head turned, on the left,
and Sohn and Hildebrandt in
impassive, authoritarian profile
opposite – may be a reference to
the situation in Düsseldorf at the
time. While Lessing was certainly
highly regarded, he was never-
theless self-employed, while
Hildebrandt had been on the staff
of the Academy since 1836, and
Sohn since 1838.

73

73
Alfred Rethel
1816 Diepenbend/Aachen–1859
Düsseldorf
The Artist's Mother, 1833/35
Oil on canvas, 61 × 47 cm
Purchased in 1935 from the Sohn-
Rethel Collection, Düsseldorf

Rethel painted his mother,
Johanna, the daughter of an
Aachen manufacturer, with the
same keen eye that caught the
subtleties of the white lace bonnet
and the embroidery of the Indian
shawl. After 1847 this painter lived
most of his professional life in
Aachen, and was always very
close to his mother. Yet he did
not hesitate to record her serious,
distinctly severe appearance,
imparting her with a look that
signals the distance she maintains
from the viewer.

74
Ferdinand Georg Waldmüller
1793 Vienna–1865
Hinterbrühl/Vienna
*The Mother of Captain von Stierle-
Holzmeister*, c.1819
Oil on canvas, 54 × 41 cm
Purchased in 1909 from Kunst-
handlung Artaria & Co., Vienna

Commissioned by Captain Stierle-
Holzmeister, it was in 1819 that
Waldmüller painted this portrait
of his mother, Henriette Mirk, the
wife of an eminent civil servant
but who, at one point, was a
soubrette at the Hofburg Theatre
in Vienna. Waldmüller himself
saw this painting as a key point
in his development, for he only
fully appreciated the importance
of studying from life when the
Captain asked for this elderly lady
to be painted with all her idiosyn-
crasies. In exactly capturing her
external appearance, Waldmüller
came so close to his subject's
essential nature that her expres-
sion of good-tempered kindliness
leads us to ignore the modish false
curls and the tightness of the
Empire dress for which she has
grown too ample.

74

75
Ferdinand Georg Waldmüller
1793 Vienna–1865
Hinterbrühl/Vienna
Early Spring in the Vienna Woods,
1864
Oil on canvas, 42 × 54 cm
Purchased in 1905 from Kunst-
handlung Friedrich Schwarz,
Vienna

With their relative positions articu-
lated through the use of light and
shade, the beech trees vividly
stand out against the blue sky,
the vitality of the coming spring
visible in their bright-breaking
buds. Compared to the sunlit trunk
of the hornbeam, the children are
almost too small. Their division
into two groups leads the eye into
the depths behind.

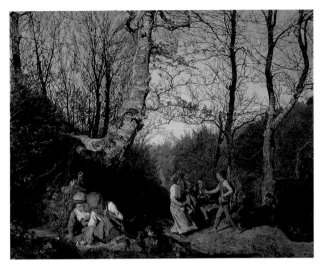

75

76
Ferdinand von Rayski
1806 Pegau–1890 Dresden
Haubold von Einsiedel, 1855
Oil on canvas, 73.3 × 61.9 cm
Purchased in 1906 from Adolf, Graf
von Einsiedel auf Milkel

The young Count Haubold von
Einsiedel, son of the High Cup-
Bearer to the King of Saxony, looks
out calmly and confidently at the
viewer. In the unusually pale back-
ground – with its shimmering hint
of blue, giving the figure a certain
spatial autonomy – and in the
frank and simple rendering of
form, Rayski has found a solution
that answers particularly well to
the openness and vitality of the
11-year-old boy. This formal simpli-
city and the modern, tonal palette
anticipate the paintings of Manet,
and thus make this an outstanding
example of the portrait-painting of
its time.

76

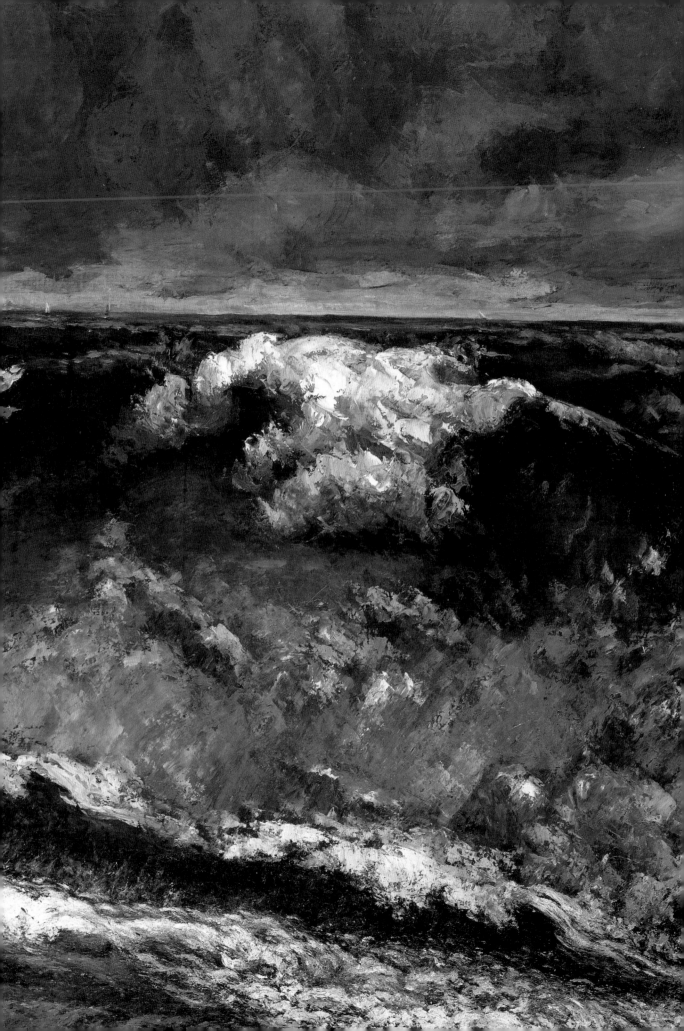

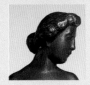

French Painting and Sculpture

Every visitor notices the gold inscription on the pediment of the Alte Nationalgalerie: 'To German art, MDCCCLXXI.' This is doubly misleading because 1871 – the year of the establishment of the German Empire – is of no particular significance in relation to the building, and the dedication to German art signifies a later narrowing of the international ambitions of the Wagener collection. Although this stance was challenged from the start, the acquisition of foreign works was excluded for the first 30 years. The political reasons for this are evident, and it is easy to understand how a generation of intellectuals turning towards Europe, in around 1900, wanted to break from this narrowness, and that the financial support necessary for such purchases came from liberal bankers and industrialists, often of Jewish origin. Against the express wishes of Emperor Wilhelm II, to whom, as King of Prussia, the museums were subordinated, Hugo von Tschudi (the director of the Nationalgalerie from 1896 to 1908) seized the opportunity. With a few exceptions, the French paintings and sculptures in the Gallery were purchased by him. The exhibition of the first French acquisitions in 1897 was a sensation. At that time, only a few European museums had begun to open up to this kind of art. Manet's *In the Winter Garden* and Cézanne's *Mill on the Couleuvre at Pontoise* were the first of these artists' works to be purchased by a museum.

Tschudi also formed a small collection of works by earlier precursors of the Impressionists. He bought *The Grove, or the Admiral's House in Hampstead*, a little masterpiece by John Constable. He acquired works by painters of the Barbizon School or those associated with it, namely Corot (one of his morning-fresh Seine landscapes), Daubigny and Courbet. In the latter's *Wave*, the element of water and the 'element' of colour become identical – both dominating the painting, and sharing the same turmoil and the same exclusive sovereignty. This, one of Courbet's late works, was painted shortly before his involvement in the Paris Commune radically altered his life.

By then, the 'Batignolles School,' a group of painters centred around the cosmopolitan Edouard Manet, had already been formed. At the Café Guerbois, where they met at least once a week, they engaged in debates about art and also discussed strategies to win the support of the public for their work, having been rejected by the juries of official exhibitions. Their first joint exhibition in 1874, which would be followed by seven more, saw them scorned as 'Impressionists,' the name being derived from the title of one of Claude Monet's paintings. From the year of that memorable exhibition dates the Nationalgalerie's *Summer* by Monet; its sole subject, full of wind and light, is expressed solely through paint and with no modelling or any reliance on draughtsman's devices. The Gallery's four Monets were all painted between 1867 and 1880, impressively

illustrating the earliest phase in the subsequent development of this artist, who lived until 1929, the last of the Impressionists to pass away. The three paintings by Pierre-Auguste Renoir were painted in the same period, but display a different approach. The largest, *Children's Afternoon at Wargemont*, clearly attempts to meet the demands of bourgeois portraiture by ensuring a linear clarity to the forms without losing the surface effect of pure, luminous colour.

The colourful light that radiates from the painting, rather than only illuminating and modelling the objects within, is typical of the Impressionist room as a whole. We find it again in the three paintings by Edouard Manet, all works of his last years. While *White Lilac* represents Manet's aphoristic, spontaneous, still-life painting in all its virtuoso light-footedness, *In the Winter Garden* is one of those society paintings whose conflict-ridden stillness allows us to understand what a commentator on Manet described as 'the secret of secretlessness.' Here we see Manet as a 'painter of modern life.' In its abandonment of the cult of the eternal for devotion to the transient charm of the moment, *In the Winter Garden* offers a vivid and concise expression of the problems and opportunities of modernity.

Compared to this highly communicative art, Cézanne's three works, each a decade apart, illustrate a loner's patient progress towards a painting sparing of content – in which gradations and contrasts of colour replace everything: mass, space and movement – whose elements are maintained in an unstable and thus lively equilibrium. This dissolution of pictorial line can be seen in the classic *Mill on the Couleuvre at Pontoise*, but an even clearer demonstration of how longstanding was this tendency is given by the early expressive *Still Life with Fruit and Crockery* (not featured here); Twenty years later, the radiant, timeless *Still Life with Flowers and Fruit* represents the culmination of the process, in the effortless emergence of form and space in surface, of light and space in colour.

Among sculptors, only the Italian Medardo Rosso created an equivalent to Impressionist painting, subjugating the tangible, durable material to the expression of fleeting perceptions and the most subtle mental states. Rodin's outstanding sculpture, on the other hand, has only a very superficial link to Impressionism, seen in the broken surfaces of his works. The expressive naturalism of his early piece, *The Iron Age*, symbolically charged from the beginning, later provides the starting point for a re-evaluation of the ambiguous, the provisional and fragmentary that is the founding moment of modern sculpture – a period that is, however, unrepresented in the Nationalgalerie's collection. In contrast to Rodin's impassioned late work, Aristide Maillol attempts to establish a new statics of stillness and positivity.

Claude Keisch

77
Eugène Delacroix
1798 Charenton-Saint-Maurice–1863 Paris
Seated Nude (Mademoiselle Rose), c.1820
Oil on paper, laid on canvas, 81.5 × 65 cm
Purchased 1986

The 22-year-old Delacroix is said to have been inspired to create this exploration of the shimmering, pallid-rosy modulations of flesh under lamplight by his study of Rubens' paintings in the Louvre. Enthused by these new possibilities, Delacroix declared that only 'yesterday evening' had he learnt to paint.

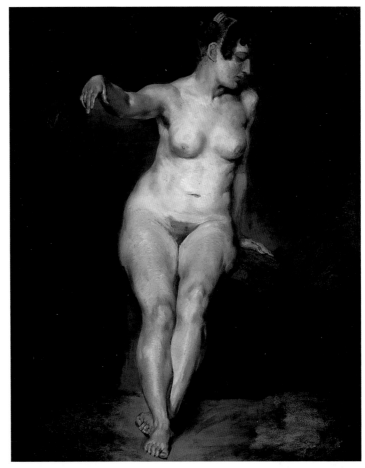

77

78
Camille Corot
1796–1875 Paris
Seine Landscape near Chatou, c.1855
Oil on canvas, 37 × 64 cm
Purchased in 1941

Returning to the familiar Ile-de-France after his journeys to Italy, Corot took up with the realist painters of the Barbizon School. In his later years he repeatedly sought to capture the same fresh, misty morning light on the banks of the Seine in subtle silver-greys. The inhabitants of these enchanting landscapes could as easily be mythological figures as peasant women and fishermen.

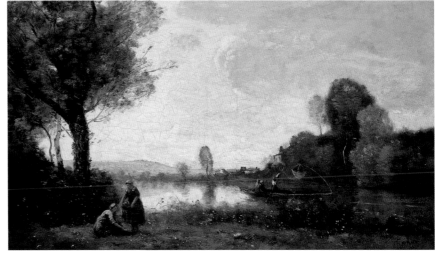

78

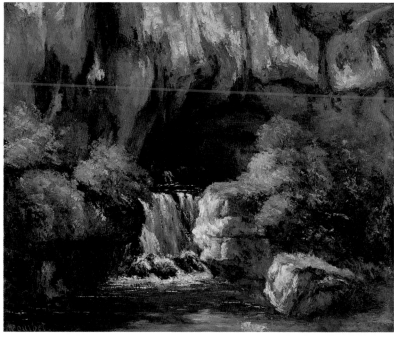

79

80

79

Gustave Courbet
1819 Ornans (Doubs)–1877 La Tour-
de-Peilz (Switzerland)
The Source of the Lison, c.1864
Oil on canvas, 65.5 × 80.5 cm
Gift of Eduard von Schwartzkop-
pen and the Berliner Handelsge-
sellschaft, 1969

Rock, water and vegetation are
often to be found in Courbet's
paintings. They are all fused
together in the materiality of
colours shot with gold, forcefully
applied with the palette knife
and bringing life and energy to
the erotic symbolism of cavern
and spring.

80

Gustave Courbet
1819 Ornans (Doubs)–1877 La Tour-
de-Peilz (Switzerland)
The Wave, 1869/70
Oil on canvas, 112 × 144 cm
Gift of Prince Guido Henckel von
Donnersmarck, 1906

The legacy of Romanticism lives on
in Courbet's realism: the search for
the elementary. Wild and forceful,
the waves and clouds roll forward,
separated by the horizon, the only
straight line in the composition.
The paint, thickly applied with
brush and palette knife, is also
elementary and absolute in its
materiality. In the poetry of
Baudelaire and Victor Hugo, the
ocean that Courbet encountered
at Etretat on the Normandy
coast stood for infinite renewal,
fecundity and danger, but also
for political turmoil and rebellion.

81

Edouard Manet
1832–1883 Paris
In the Winter Garden, 1878/79
Oil on canvas, 115 × 150 cm
Gift of Eduard Arnhold, Ernst and
Robert von Mendelssohn and Hugo
Oppenheim, 1896

Is this a double portrait, a modern
morality painting or even one of
the then-popular 'problem paint-
ings,' whose mysterious central
character was always a woman?
The Guillemets were friends of
Manet's and ran an elegant fashion
house. The scene is set in a hot-
house, such as the painter's friend
Emile Zola had used for erotic
scenes. Bright light, silence, the
mind elsewhere, a moment
stopped in time. At the centre of
the composition the lady's hand
dangles, indecisive, alongside her
husband's cold cigar.

81

82

Edouard Manet
1832–1883 Paris
*White Lilac, c.*1882
Oil on canvas, 54 × 42 cm
Bequest of Felicie Bernstein, 1908

Having tried his hand at almost
every kind of painting, Manet
became a master of the aphoristi-
cally simple still life. During his
last long illness he painted the
flowers his friends had brought
him. His attention was captured
as much by the refraction of the
light and the stems through the
crystal as by the white-in-green of
the lilac, but such phenomena are
not so much recorded as delicately
suggested.

82

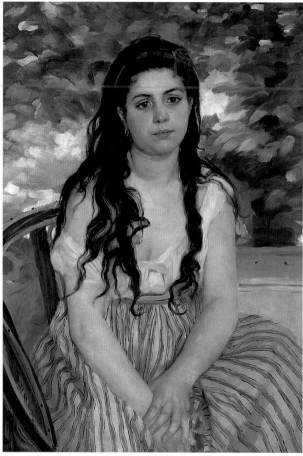

83

84

83
Pierre-Auguste Renoir
1841 Limoges–1919 Cagnes
In Summer, 1868
Oil on canvas, 85 × 59 cm
Gift of Mathilde Kappel, 1907

The Impressionist light fills the background without transfiguring the subject herself: the girlish Lise Tréhot, mistress to the 27-year-old Renoir, is a highly concrete presence. Courbet's influence is palpable. The model's modest background meant that the painting was exhibited at the Paris Salon with the anonymous title: *In Summer, a Study*.

84
Pierre-Auguste Renoir
1841 Limoges–1919 Cagnes
Children's Afternoon at Wargemont, 1884
Oil on canvas, 127 × 173 cm
Gift of Karl Hagen, 1906

In several large, stagy group portraits commissioned by rich bourgeois patrons, Renoir offered an unconventional reinterpretation of an old theme. Unlike their baroque predecessors, the figures portrayed hardly take any notice of the viewer, being entirely engaged with their modish surroundings. Renoir was invited, on many occasions, as a guest to the diplomat Paul Bérard's country estate in Wargemont on the Normandy coast, in order to paint the members of his family. This picture was painted at the high point of a cool, 'classicizing,' phase in his work.

85
Edgar Degas
1834–1917 Paris
Conversation, c.1882/83
Pastel, 65 × 86 cm
Gift of Oskar Huldschinsky, 1896

The occasion is undefined and
their identities are unclear; the
three women are turned away
from one another, in a half-shade
that does nothing to dim the
iridescence of interwoven red,
green and blue. The composition
is strongly asymmetric, the per-
spective broken up: an equivalent
of modern big-city life. After the
mid-1880s Degas increasingly came
to prefer pastel to oil, using it even
for large-format works. In his work
in pastel, its habitual powdery
softness is no longer evident.

85

86
Claude Monet
1840 Paris–1926 Giverny
Saint-Germain l'Auxerrois, 1867
Oil on canvas, 79 × 98 cm
Gift of Karl Hagen and Carl
Steinbart, 1906

Monet was not yet painting
cathedral façades dissolved in light,
so this building still has mass and
contour. But the square in front
lies in full sunlight, and the blue
shadows and the clustered figures
create a bewildering patchwork
that contrasts with the broad
expanse of the sky.

86

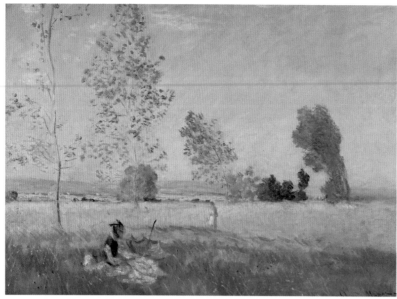

87

88

87

Claude Monet
1840 Paris–1926 Giverny
Summer, 1874
Oil on canvas, 57 × 80 cm
Gift of Karl Hagen and Carl
Steinbart, 1906

This was painted in the year that
another of Monet's pictures gave
its name to Impressionism. Seen
from the slight shade of the fore-
ground, the brightness of the corn-
field and the translucent air above
are all the more dazzling. No
volumes can resist this luminous
flood of light, carried across the
surface by delicate brushstrokes.

88

Claude Monet
1840 Paris–1926 Giverny
View of Vétheuil, 1880
Oil on canvas, 60 × 100 cm
Gift of Karl von der Heydt, 1896

Twisted scribbles of colour
unambiguously betray the way
this painting was made. The
seated woman with the parasol
seems weightless to the point of
invisibility, even more so than
in *Summer*. Monet painted the
poplar-lined banks of the Seine
near Vétheuil again and again, as,
for example, in a series of paint-
ings of ice on the water, done in
the same year as the National-
galerie's painting.

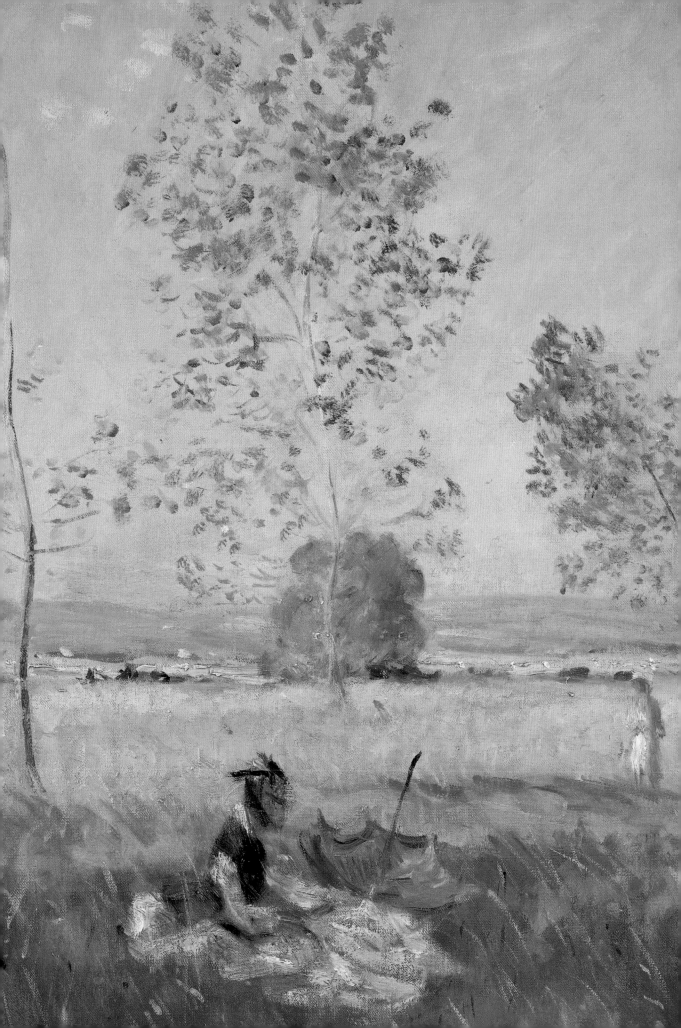

89

Paul Cézanne

1839–1906 Aix-en-Provence

Mill on the Couleuvre at Pontoise, 1881

Oil on canvas, 72.5 × 90 cm

Gift of Wilhelm Staudt, 1897

This was painted in the course of a lengthy stay in Pontoise, near Cézanne's friend Camille Pissarro. The faithfully rendered, common-place agricultural landscape of the village finds itself ennobled by the sophisticated colour architecture. Tonality and local colour being abolished, the graduated greens, blues and ochres form an even tapestry of light.

90

Paul Cézanne

1839–1906 Aix-en-Provence

Still Life with Flowers and Fruit,

*c.*1888/90

Oil on canvas, 65.5 × 82 cm

Gift of Eduard Arnhold, 1906

The modest wild flowers and the ginger jar Cézanne so often painted have here a drapery as sumptuous as in a baroque still life. An emphatic, yet not entirely stable, open geometry organises the luminous, pure, shadowless, 'modulated' colours on a surface in which all spatial depth is subtly dissolved.

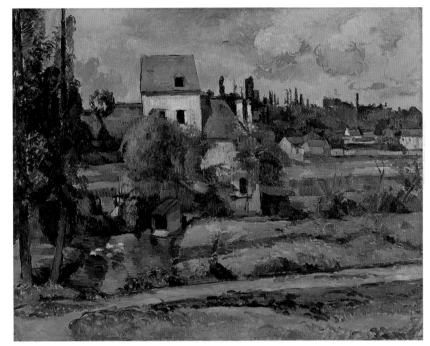

89

90

91

Auguste Rodin
1840 Paris–1917 Meudon
The Iron Age, 1875/76
Bronze, 180 × 66 × 52 cm
Gift of Karl von Wesendonck, 1903

With its precisely observed, vibrantly supple modelling, Rodin's first masterpiece, produced in his mid-30s, was so heedless of academic convention that it was thought to have been made from a cast of a living person. The expression is full of the same conflict between the yearning for life and resignation in the face of death as informs the figures in his *Gates of Hell* a few years later.

92

Auguste Rodin
1840 Paris–1917 Meudon
Man and his Thought, 1899/1900
Marble, 77 × 46 × 55 cm
Donated by the heirs of Felix
Koenigs, 1901

The title, rich in symbolic allusion,
reflects Rodin's lifelong preoccupa-
tion with human creativity. Like so
many of his works, this is based
on a spontaneous inspiration:
two small unrelated figures from
his *Gates of Hell* are here combined.
The uncarved remainder of
the large stone, which contrasts
suggestively with the smoothly
polished bodies, is not unfinished,
but was always intended to be left
like this.

93

Aristide Maillol
1861–1944 Banyuls-sur-Mer
Eve with Apple (Eve à la pomme), 1899
Bronze, 58 × 22 × 12.5 cm
Purchased in 1978 from a
commercial dealer

Whether decorative painting or
ceramics, or sculpture in wood or
bronze, all of young Maillol's work
tended towards simplicity, tangi-
bility, maturity and harmony of
form. The apple that Eve hands to
her imaginary partner brings about
an effortless re-centering of the
rhythm of the body.

92

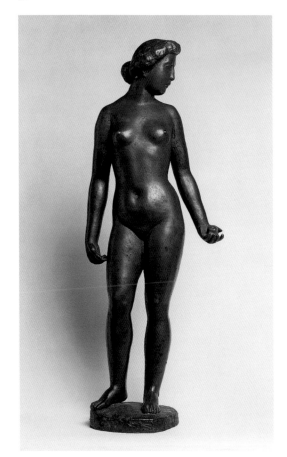

93

94

94
Medardo Rosso
1858 Turin–1928 Milan
Sick Old Man, 1889
Wax over plaster core,
23 × 21.5 × 22.5 cm
Purchased in 1972 from a
commercial dealer

In the modelling, which leaves a
great deal open-ended – thereby
avoiding an unequivocal delimita-
tion between body and space,
and subordinating everything to
the suggestion of atmosphere –
Medardo Rosso's sculpture comes
close to the effects of Impression-
ist painting. The mood is one of
foreboding, evoking solitude,
weariness and the closeness
of death.

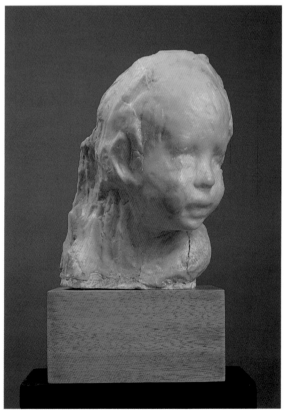

95

95
Medardo Rosso
1858 Turin–1928 Milan
Bust of Oskar Ruben Rothschild, 1892
Wax over plaster core,
23 × 16 × 12 cm
Purchased in 1972 from a
commercial dealer

As in a snapshot, extremely alive
and yet blurred, the four-year-old
child 'appears' in the true sense of
the word, and the veiled modelling
that underlines the translucence of
the wax suggests the half-light of
an interior space.

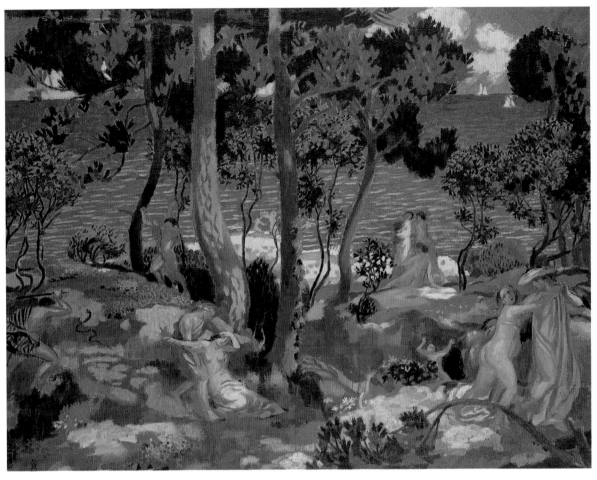

96

96
Maurice Denis
1870 Granville–1943 Paris
*Eurydice, c.*1903/04
Oil on canvas, 75.5 × 116.8 cm
On long-term loan from the Ernst
von Siemens Foundation

This picture is one of what the artist
called his *'plages mythologiques'* or
'mythological beaches.' Scattered
through the decorative, tapestry-like
composition, one can recognize,
though not without some difficulty,
several scenes from the Orpheus
myth, which narrativize the land-
scape and put into question the
tranquillity of the pastoral scene.

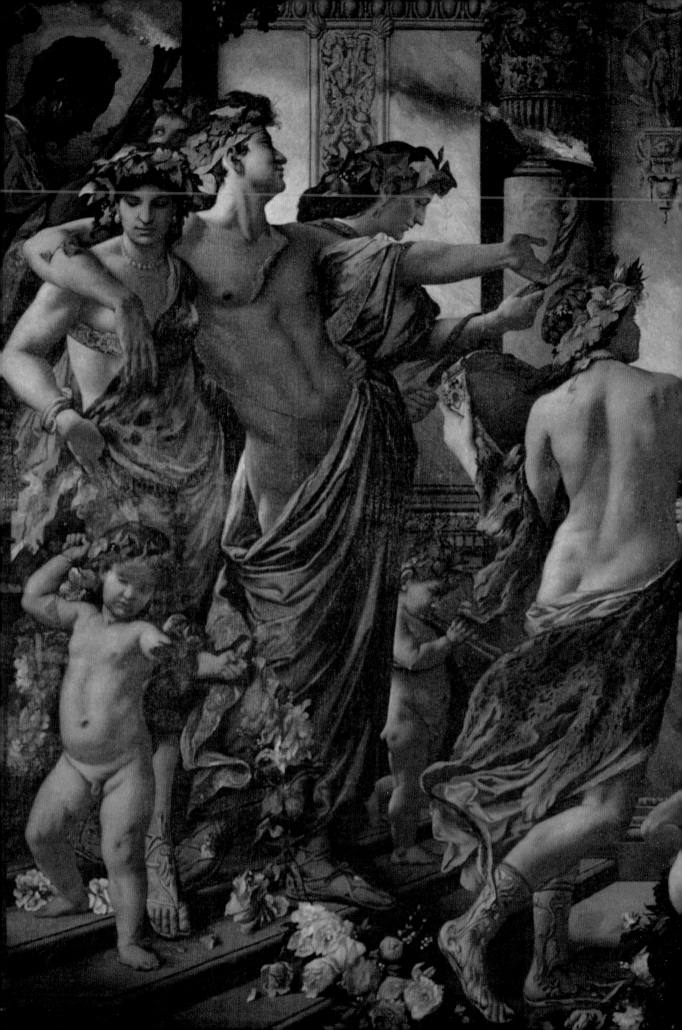

The Art of the *Gründerzeit* and the 'German Romans'

It needs a certain effort of historical imagination to realise that almost everything assembled on the middle floor of the Nationalgalerie belongs to the same period, the few decades between 1860 and 1880–90, the work of a generation of artists born 1825–30 and 1840–45. Idealism, Naturalism, Impressionism: the contrasts could not be greater. An idea of the tensions of this pivotal period can be gained by comparing a number of works created within a few years of each other, so virtually simultaneously, and brought together here under the same roof: Anselm Feuerbach's *The Banquet* with Adolph Menzel's *The Iron-Rolling Mill (Cyclops)*, Liebermann's *Goose Pluckers* with Monet's *Summer*, Aldolf von Hildebrand's *Sleeping Shepherd Lad* with Rodin's *The Iron Age*. A glance at the individual artists, too, would show that they hardly saw themselves as 'representing' a shared programme or a shared style for any length of time. Even if they sometimes formed groups in order to more effectively assert themselves against academies and conventions, each artist underscored his individuality with some novel emphasis in his work. This is a distinctively modern trait, and this habit of keeping one's distance can also be seen in the life and work of the 'German Roman' painters Arnold Böcklin, Anselm Feuerbach and Hans von Marées.

All three worked for longer in Italy (Rome, Florence and Venice) than in their own country. But unlike their predecessors at the turn of the century, who had found in Rome the artistic capital, the place of encounter that Germany was not, these painters of the *Gründerzeit* – the German term for the early years of the new Empire, marked by the huge expansion of industry – were looking for extra-territoriality, somewhere to stand outside their own country and its situation. From their 'off-shore island,' they could counter the fragmentary reality of capitalism with the art of a closed, ordered system; 'idealism' in the end meant no more than this. For Feuerbach, the spiritual realm of art stood under the sign of antiquity or, more generally, of culture; for Böcklin, under the sign of a mythopoeic and sometimes cosmic imagination; for Marées, under the sign of a timeless formal unity between Man and Nature, a Nature transfigured by a colour that blazes out from unfathomable darkness. It was Hans von Marées, who was misunderstood by his contemporaries and never exhibited, who had the most lasting influence on later generations of artists. The contradictions of Feuerbach's approach – which involved both rejecting the present and striving for real recognition – disturbed critics and public alike for some time, before the posthumous publication of his letters and papers stylised him as a martyr to Germany's nostalgia for classicism. The seemingly naïve obviousness of Böcklin's subjects bridged the gap between the primeval time of myth and the bourgeois present, preparing the way for Symbolism and Surrealism.

Anselm Feuerbach, detail of *The Banquet*, 2nd Version, 1871–73/74 (cat. 107)

Under the completely different conditions governing the public reception of sculpture, Marées' friend Adolf von Hildebrand was, however, able to establish himself in Munich after his years in Italy. He successfully gave concrete expression to his artistic ideal of clear and unambiguously legible form, and won official commissions for monumental sculpture. Hildebrand's theoretically grounded aesthetic represents an antithesis to the neo-baroque naturalistic sensuality of the work of Berlin sculptor Reinhold Begas. In the Nationalgalerie one can also find a public art of social and political prestige, its complexities only poorly reflected in such concepts as 'salon painting,' whose very existence, its sometimes enormous success, and its connections with business and the state provoked some artists to an elitist counterreaction.

These few were certainly not ignored by the Nationalgalerie during their lifetimes. Max Jordan, its first director, had a very high opinion of Böcklin, Feuerbach and Hildebrand, and was able to push through significant acquisitions against widespread objections; that his efforts did not always meet with success is evidenced by the memorable debate around Böcklin's *Elysian Fields*. It was otherwise Hans von Marées, whose reputation was only just rescued from oblivion shortly after 1900, when a collection of his work was bequeathed to the Gallery by the art-theorist Konrad Fiedler, to be added to thereafter. Even if major, large-format paintings have been missing since 1945, the stunning collection of works by the 'German Romans' remains one of the most impressive in the Alte Nationalgalerie.

A completely different, entirely concrete and contemporary world is revealed in Menzel's *The Iron-Rolling Mill (Cyclops)*, a grand tableau of modern industry. For all the fine detail of technical processes and social relations, studied by the painter in a modern factory in Upper Silesia, it deploys the drama of light and the idea of elemental fire to impressive effect. The same artist's *Ball Supper* is set at the other end of the social scale, among the aristocracy. It is as if he had wanted to paint a series, as he had done with his paintings of Frederick the Great, but this time focused on the present: a novel-like panorama of the imperial age, a counterpart to the work of Fontane or Emile Zola.

Claude Keisch

97

97
Adolph Menzel
1815 Breslau–1905 Berlin
The Iron-Rolling Mill (Cyclops),
1872–75
Oil on canvas, 158 × 254 cm
Purchased in 1875 from Adolph von
Liebermann

In Menzel's world of universal
motifs we have the first artistic
representation of modern industry.
The collaboration of man and
machine, which the artist had
conscientiously studied in Upper
Silesia, is here summed up in all
its different aspects through a
complex composition centred on
the flywheel in the background.
Yet this is much more than docu-
mentation: it is an evocation of the
magic of fire, whose reddish glare
usurps the dominion of the
distant daylight.

98

98
Adolph Menzel
1815 Breslau–1905 Berlin
Ball Supper, 1878
Oil on canvas, 71 × 90 cm
Purchased in 1906 from Emil
Meiner, Leipzig

Reflecting the experience of the
big city, Menzel's late paintings all
depict crowds, and overwhelm the
viewer with an infinite wealth
of detail that takes on a distinctly
satirical edge, such as here, in
which the trials and tribulations
of upper-class existence are
illustrated. The view over the
crowded company from above
leads from the packed foreground
to a pyrotechnical display of light
and colour in the neo-baroque
architectural fantasy that fills the
upper half of the painting.

99
Gustav Eberlein
1847 Spickershausen–1926 Berlin
Thorn Puller, 1880–86
Marble (on original wood plinth),
156 × 57 × 78 cm
Purchased from the artist in 1887

In being taken from a famous
antique sculpture, the subject itself
underscores the work's distance
from everything classical. The neo-
baroque Berlin sculptor does not
aspire to the ordered proportion
of the body, but seeks an endless
spiral movement and an easy grace,
a charm of surface and narrative
detail.

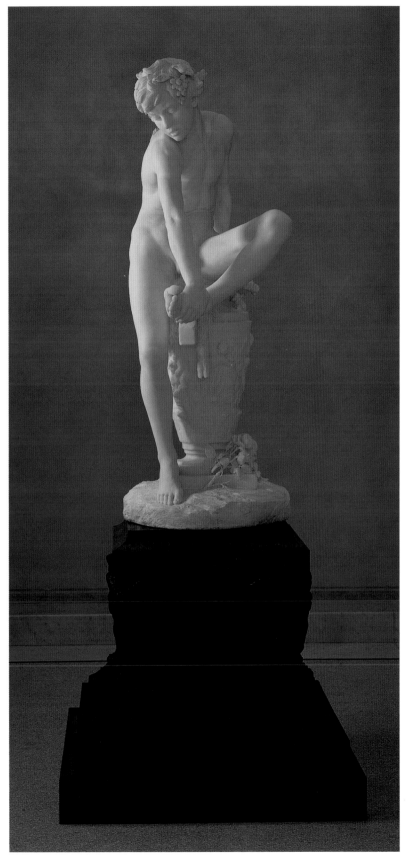

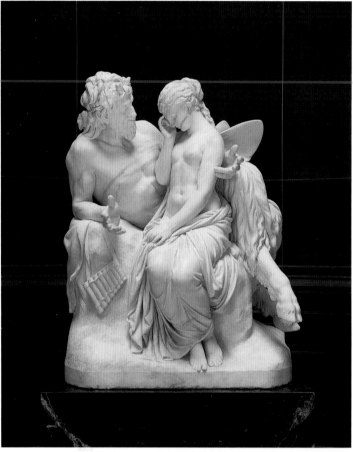

100

100
Reinhold Begas
1831–1911 Berlin
Pan Comforting Psyche, 1857/58
Marble, 132 × 101 × 67 cm
Purchased 1934

In this scene from the well-known myth of Cupid and Psyche, Christian Daniel Rauch's young pupil Begas brings a childlike sense of the comic to Psyche's affecting grief for her lost lover. Classicizing abstraction has given way to sensuous intimacy and the pleasure of narrative. With this group the sculptor won immediate recognition.

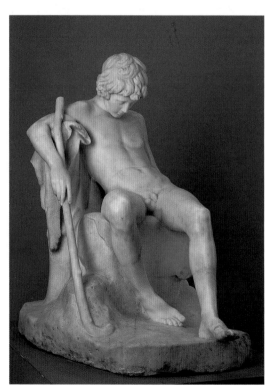

101

101
Adolf von Hildebrand
1847 Marburg–1921 Munich
Sleeping Shepherd Lad, 1871–73
Marble, 105 × 68 × 106 cm
Acquired in 1902 with the Konrad Fiedler collection

Despite the echoes of antiquity in the subject, Hildebrand's art has left neoclassicism behind. It strives not for recognisable formulae but for a verisimilitude mediated by clearly legible, objective forms. Without any anecdotal decoration or mythical trimmings, we see in the shepherd boy only the unconsciousness of sleep and heavy limbs.

102

Anselm Feuerbach

1829 Speyer–1880 Venice
Self-portrait, 1873
Oil on canvas, 62 × 50 cm
Purchased 1899

In almost 30 self-portraits, with a defiance bordering on insolence, Feuerbach depicts an artist's self-assertion in the face of bourgeois society. This painting, produced in 1873, just before he began his professorship at Vienna, is noticeably dry and restrained in grey and black, but it has a more expansive moment in the silhouette of the curly hair.

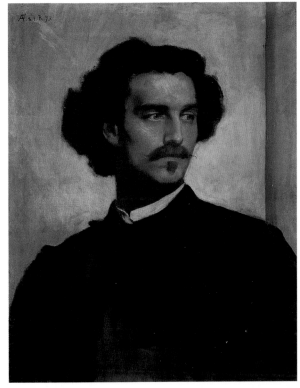

102

103

Arnold Böcklin

1827 Basle–1901 San Domenico di Fiesole
Self-portrait with Death Playing the Violin, 1872
Oil on canvas, 75 × 91 cm
Purchased 1898

The voice from beyond the grave that consoles and inspires the artist is supra-personal, inspired as it is by the late-medieval dance of death; heard only by the genius, it is his one possession, and the grinning spirit of negation is answered in creative activity. The 45-year-old creator of this painting stands just at the beginning of his success.

103

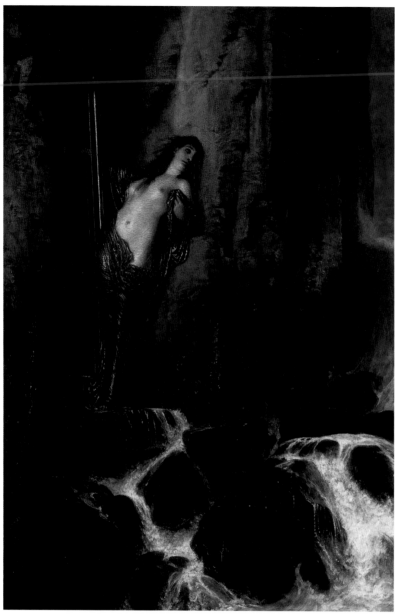

104

104
Arnold Böcklin
1827 Basle–1901 San Domenico
di Fiesole
Breakers (Roar of the Sea), 1879
Oil on wood, 121 × 82 cm
Purchased 1897

A Romantic experience of synaes-
thesia: the roar of the breakers are
personified in the harp-music of
a mysterious female figure, half-
mythical and half-operatic, who
wears an almost startled expres-
sion. The concern for the poetry
of nature is matched by close
observation, evidenced here in
the rivulets of water.

105
Arnold Böcklin
1827 Basle–1901 San Domenico
di Fiesole
The Isle of the Dead, 1883
Oil on wood, 80 × 150 cm
Purchased 1980

Conceived as 'a picture for dream-
ing,' produced in five variations,
and reproduced and imitated
countless times, *The Isle of the Dead*
remains Böcklin's most famous
painting. With the stage-like
symmetry of the island rising from
the smooth, mirror-like surface of
the water, the evening light and
the solemn and mysterious funeral
barge, it captured the imagination
of generations.

106
Arnold Böcklin
1827 Basle–1901 San Domenico
di Fiesole
Honeymoon, 1878
Oil on canvas, 80 × 59.5 cm
Purchased 1910

The young woman dreamily
expectant, the young man in his
flowered hat full of the spirit of
adventure, dreaming of afar: the
roles are theirs for all eternity.
It is an allegory, but the narrow
section of landscape under the
blue sky is populated and appears
highly contemporary.

105

106

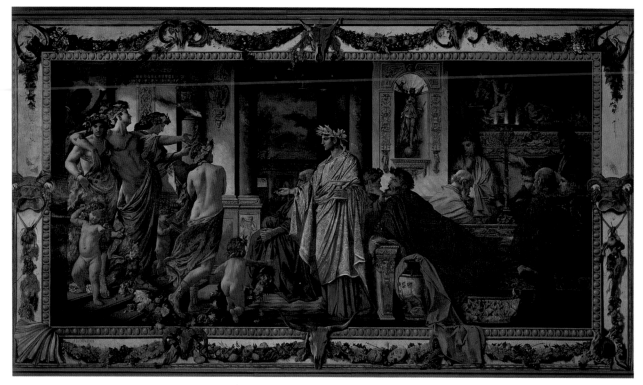

107

107
Anselm Feuerbach
1829 Speyer–1880 Venice
The Banquet, 2nd Version, 1871–73/4
Oil on canvas, 400 × 750 cm
Purchased from the artist in 1878

Behind the heavy, illusionistic, Early-Imperial pomp of this stage-like setting (continued on the painted frame) is an important representation of German Idealism. Feuerbach, a great admirer of antiquity by reason of his late-Romantic frustration with modern capitalism, represents here the opposition and reconciliation of intellectual reflection and sensual pleasure under the sign of the god Dionysus. The gold-crowned poet Agathon and the half-naked womanizer Alcibiades are two different aspects of the same artist.

108
Anselm Feuerbach
1829 Speyer–1880 Venice
Nanna, 1861
Oil on canvas, 64 × 51 cm
Acquired in 1902 as part of the
Konrad Fiedler collection

Few artists' models became as
famous as the majestic Anna Risi,
a cobbler's wife. For five years
Feuerbach venerated her, covering
her in jewellery and painting her
in costume for different roles; she
was always depicted as a classical
beauty, distant and rejecting any
advances.

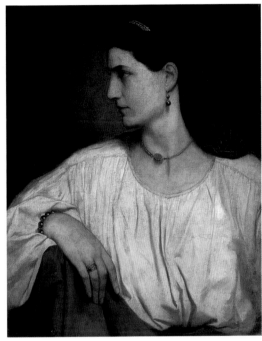

108

109
Anselm Feuerbach
1829 Speyer–1880 Venice
Ricordo di Tivoli, 1866/67
Oil on canvas, 194 × 131 cm
Acquired in 1902 as part of the
Konrad Fiedler collection

In response to the genre-like
peasant paintings of his contempo-
raries, Feuerbach painted timeless
idylls almost monumental in
effect. Landscape is here depicted
less as concrete nature than as
the vastness of world. The girl is
turned towards it, while the boy is
pensively absorbed in the sound of
his lute: the usual gender roles are
thus reversed.

109

110

110

Hans von Marées
1837 Elberfeld–1887 Rome
Oarsmen. Study for a Fresco at the
Zoological Station in Naples, 1873
Oil on canvas, 136 × 167 cm
Gift of Adolf von Hildebrand, 1907

After decades during which fresco
painting had been governed by an
abstractive idealism, these murals
at the German zoological station in
Naples saw concrete neighbouring
localities and more especially the
sea itself brought into the building,
these realities being dignified only
through purity of compositional
form. The figures, mostly of
ordinary people, were the subjects
of full-size studies in oil.

111

Hans von Marées
1837 Elberfeld–1887 Rome
Self-portrait with Yellow Hat, 1874
Oil on canvas, 97 × 80 cm
Purchased in 2000

Before a Tuscan landscape at dusk,
the 36-year-old painter presents
himself with matter-of-fact
objectivity: not striking a pose, he
appears more the landowner than
artist. His piercing eyes are turned
on the viewer, and he nervously
grasps his walking stick with both
hands. The painter of the Naples
frescoes saw his art as a commit-
ment to the spiritual.

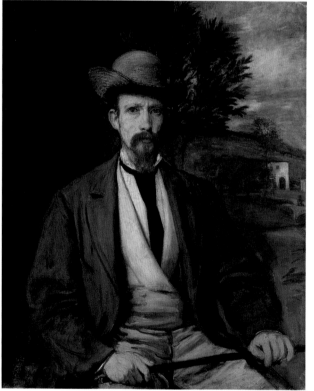

111

112

Hans von Marées
1837 Elberfeld–1887 Rome
Three Youths in an Orange Grove,
1878–83
Oil and tempera on wood,
98.7 × 67 cm
Acquired in 1902 as part of the
Konrad Fiedler collection

The space of Marée's paradisaical
landscape – inhabited by naked
figures, timeless and beyond the
reach of fate – is structured by the
orange trees of Southern Italy,
with their delicate, columnar
trunks and their fruits glimmering
in the evening shade. The colour
glows, mysterious and precious,
from the depth of many trans-
lucent layers.

113

Hans von Marées
1837 Elberfeld–1887 Rome
St George, 1880–82
Oil and tempera on wood,
180 × 105 cm
Gift of Adolf von Hildebrand, 1907

In the last years of his life, Marées'
'quest for the absolute' led him to
paint several monumental works
in a number of panels. This
St George is the first version of a
triptych of three knightly saints.
The composition is dominated by
a geometry of taut, dynamic diago-
nals and an abstract, pre-conceived
formal conception, which does
not, though, exclude the poetry of
glowing rust and gold, or inhibit
the spontaneity of the brushwork,
which remains fluent throughout
as the painting is built up layer
by layer.

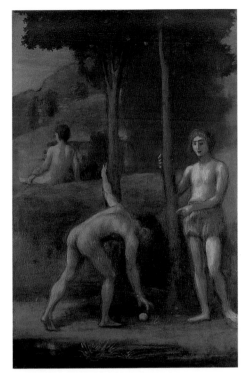

112

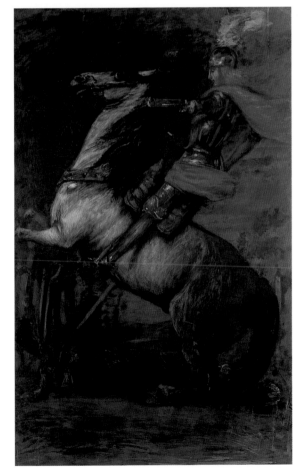

113

Painting in Munich and the Leibl Circle

The Munich painting of the second half of the nineteenth century was unmistakeably influenced by the First International Art Exhibition, which was held in the city in 1869. The non-academic paintings of the Barbizon School made a great impression, and the individualistic works of Gustave Courbet were even more enthusiastically received; he made the journey to Munich himself and became a figure of fascination to the young painters around Wilhelm Leibl, and he impressed them by the strength of his personality. The retrospective element of the exhibition, too, provided an inspiration (not to be underestimated) in the seventeenth-century works of Frans Hals, whose quick-witted spontaneity and loose brushstroke technique seemed extremely modern. Even Courbet started to copy works of Frans Hals in Munich. The Munich exhibition marked the inauguration of a modernity that from that point on would break out again at intervals in another version, new each time.

Hans von Thoma's *Marsh on the Rhine* seems directly influenced by Courbet; with *Summer*, painted only three years later, he would again distance himself from Courbet's realism, falling under the influence of Böcklin, who was then living in Munich.

A characteristic of the modern Munich painting was its sketch-like character, directing the viewer's attention to the paint and the brushwork. In this respect, even some older artists could recognise themselves in the new movement. After a trip to Paris in 1851, Carl Spitzweg had already begun to render his subjects in a loose, painterly fashion. This evolution can be followed in his sequence of paintings of *The Priest as Cactus Lover*, and his *Street in Venice* seems to have been painted for its rude painterly charms alone.

However, the new developments in painting were principally the work of the 'Leibl Circle', as they were later to be known, a loose group of friends who had already coalesced around the talented Wilhelm Leibl in his student days. In late 1869, Leibl had accepted Courbet's invitation to go to Paris, and between his return in the autumn of 1870 and his withdrawal to the countryside in 1873, the group produced a number of important works. Their painterly pursuit of artistic truth found expression most commonly in figure-painting and portraiture, and the Leibl Circle's most important achievements were in these fields. This was when the idea of the 'purely painterly' was first developed. While academic works were judged by the beauty or importance of the subject as well as by its execution, now the interest of a painting could only reside in the artist's 'handwriting', his way with the brush. 'According to my principle, it is not a question of the What but of the How, to the chagrin of the critics, journalists and the general public for whom the What is the

Hans Thoma, detail of *Summer*, 1872 (cat. 125)

essential thing,' Leibl wrote in a letter. The *Portrait of Bürgermeister Klein* and *Woman from Dachau with Child* are both marked by this deliberate concentration on painterly essentials.

The young Wilhelm Trübner's *On the Sofa* is indebted to Leibl's work, but also shows the direct influence of Dutch painting. Carl Schuch pushed the idea of 'pure painting' to an extreme for his time; he noted the colour relationships of works in the Louvre without any reference to subject matter, and he painted pictures in colour combinations worked out in advance. Others again seized on aspects of the new non-academic without making any claims to rigour. The cartoonist Wilhelm Busch, who was also a painter, had laid down his little scenes in loose brushwork from the beginning; Franz von Lenbach's enormously popular portrait art made use of the sketch as a witty gesture. With these, however, one already takes one's leave of the Leibl Circle.

Angelika Wesenberg

114

114

Wilhelm Busch
1832 Wiedensahl/Hannover–1908
Mechtshausen
*Small but Stubborn, c.*1875
Oil on wood, 24.3 × 29.3 cm
Purchased in 1936 from the artist's
family, Munich

Wilhelm Busch was famous, above
all, for his funny and cryptic
picture stories, and only after his
death did the public discover that
he had also painted all his life.
His small-format paintings, with
their light, sketch-like touch, were
influenced by Adrian Brouwer and
Frans Hals. Although generally
depicting minor episodes from
everyday life, some of his paintings
are still lifes and landscapes.
Children are often at the centre
of these lively, expressive scenes.
This picture of a stubborn,
screaming boy in simple, rural
surroundings lends dignity to
its unassuming subject with its
references to Dutch 17th-century
painting.

115

116

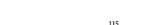

115
Wilhelm Leibl
1844 Cologne–1900 Würzburg
Portrait of Bürgermeister Klein, 1871
Oil on canvas, 87 × 67 cm
Purchased in 1906 from the
subject's family

In its rigorous frontality this
painting reminds one of Albrecht
Dürer's self-portrait of 1500, a
work that would certainly have
been familiar to Leibl, who
often copied works at the Alte
Pinakothek in Munich. The long
face, one hand resting upon the
other and his cane create a vertical
in the middle of the picture.
However, his portrait of the mayor
is not particularly heavy with
significance, but is, rather, a classic
instance of 'pure painting.' It is
a fine example of *alla prima*, i.e.
painted without preparatory draw-
ing, in short, broad brushstrokes.
The emphasis here, as in other
portraits, falls on the face and
the hands, and the dark clothing
almost melts into the background.

116
Wilhelm Leibl
1844 Cologne–1900 Würzburg
Woman from Dachau with Child,
1873/74
Oil on wood, 86 × 68 cm
Purchased in 1904 from the Elias
Collection, Brussels

As in the *Portrait of Bürgermeister
Klein*, the dark-clothed figures gaze
out with guarded looks, and here
too the emphasis falls on hands
and faces. But the woman from
Dachau and her child are seated
before a subtly modulated blue
wall. The mother wears a festive
costume with silver lace, the child
a brown outfit with paler brown
spots. The style of painting is less
purist and the relationship
is sensitively depicted. This is a
peaceful painting, focused on
not being narrative, yet the clear
diagonal from the top left to the
bottom right gives it a certain
vigorous concision and architec-
tural solidity.

117

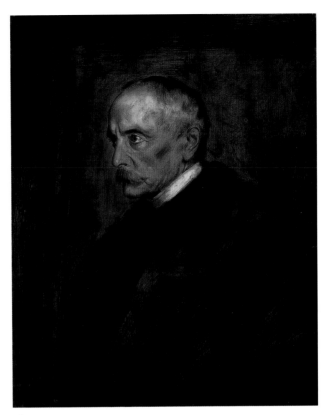

118

117
Wilhelm Leibl
1844 Cologne–1900 Würzburg
*The Poachers, c.*1882/86
Oil on canvas, stretched over
wood, 55 × 42 cm
Purchased in 1899 at Lepke, Berlin,
from the collection of Ernst Seeger

In the early 1880s Leibl was looking
for new means of expression, and
one of his ideas was to present
large-format dramatic scenes in
high contrasts. A subject suitable
for this treatment was offered by
the *Fleeing Poachers*, which he
began as a monumental painting.
But the composition didn't work
out, especially in the proportions
of the life-size figures, and in the
end Leibl cut out what he thought
were the most successful parts.
Indeed, the objective, accurate
depiction of his models that he
looked for is perhaps even more
clearly evident in the fragment.
'Leibl attacked the figures as if
with a sabre,' said one of his
biographers.

118
Franz von Lenbach
1836 Schrobenhausen/
Oberbayern–1904 Munich
*The Imperial Chancellor, Prince of
Hohenlohe-Schillingsfürst*, 1896
Oil on canvas, 74.5 × 60.5 cm
Purchased from the artist in 1897

Lenbach was especially famous for
his substantial number of portraits
of the imperial chancellor Otto
von Bismarck. As well as these
were many, no-less formal and
sumptuous portraits of artists,
scholars and politicians, rich
patrons and prominent society
figures. Yet Lenbach often painted
these backward-looking portraits
from photographs, or even on
photographs. In this way the
essential features of the face were
more easily captured, and the rest
he liked to sketch in with a light
and brilliant touch. In the acuity
of its characterisation, this
portrait of the Imperial Chancellor,
Prince Hohenlohe-Schillingsfürst,
is, without doubt, one of his
most successful.

119

120

119
Carl Schuch
1846–1903 Vienna
*Lobster with Pewter Jug and
Wineglass*, 1876/77
Oil on canvas, 61 × 75 cm
Purchased in 1905 from Kunst-
handlung Eduard Schulte, Berlin

Influenced by Wilhelm Trübner,
with whom he shared a studio, in
1876 Carl Schuch turned to still-life
painting and quickly achieved
impressive results. In this still life
with lobster and pewter jug, as in
the other with red apples – also in
the Nationalgalerie – the shimmer-
ing grey metal mediates between
the white of the tablecloth and the
dark background, with the strong
red set against them both. Soon,
however, Schuch was unhappy
with these works, and he strove
for something more sophisticated:
'My still lifes are all too obtrusive
in their reality. They lack distance,
air, the indistinct twilight of space.'

120
Carl Schuch
1846–1903 Vienna
Still Life with Partridges and Cheese,
after 1884
Oil on canvas, 76 × 63 cm
Purchased in 1907 from Kunst-
handlung Eduard Schulte, Berlin

Carl Schuch was a true colourist.
For him, the combination and
contrast of colours were more
important than subject matter. In
Paris, during the 1880s, he studied
the interplay of different colours
within paintings in the Louvre.
This *Still Life with Partridges and
Cheese* is an impressive demonstra-
tion of his subtle sense of colour.
Different shades of grey, brown
and black, with a very little red,
stand alongside each other,
advancing or retreating, all equally
playing a part in a chromatic
composition.

121

122

123

121
Carl Spitzweg
1808–1885 Munich
The Priest as Cactus Lover, 1870s
Oil on cardboard, 29 × 18 cm
Purchased in 1903 from
Kunsthandlung Helbig, Munich

Typical of Spitzweg's work is the
portrayal of loners, often strange
and cranky people whose dreams
are almost over-clearly illustrated
through their environment and
body language. Spitzweg painted
many variations on the theme of
the priest as cactus lover. In almost
all, the amateur grower leans over
admiringly towards a flowering
stem-cactus, his posture and the
curvature of the plant almost
bringing nose and bloom together.
Spitzweg often shows the priest
in his study, or as here, in a quiet
corner of the garden. It was these
humorously enigmatic pictures
that would later make him a
painter of considerable renown.

122
Carl Spitzweg
1808–1885 Munich
Street in Venice, c.1850
Oil on wood, 31.5 × 16 cm
Purchased in 1903 from
Kunsthandlung Helbig, Munich

Paintings of Venice are usually
easily recognisable as such. Here,
with the canal right in the fore-
ground and the distant view
through the canyon of houses,
such recognition comes only at
second glance. What interested
the painter, quite clearly, was the
contrast between the austere high
walls and the little group of figures
around the organ-grinder, as well
as the play of light and shade on
the square, and on the old walls.

123
Carl Spitzweg
1808–1885 Munich
Kite Flying, c.1880/85
Oil on cardboard, 38 × 12 cm
Purchased in 1908 from Galerie
Gurlitt, Berlin

Spitzweg has chosen an extremely
vertical format for this scene, as
he did for his view of Venice. Two-
thirds of the picture is taken up by
the clear blue sky, in which one
can see tiny kites. The horizon line
is broken by the city of Munich in
silhouette. On the now-brown
Theresienwiese meadows in the
foreground, we see boys with their
kites, a girl with her doll and a
mother with small children. This
is a composition as concise as it
is bold, with a rhythmical accent
in the wandering path whose
vertical is continued by the string
of the kite.

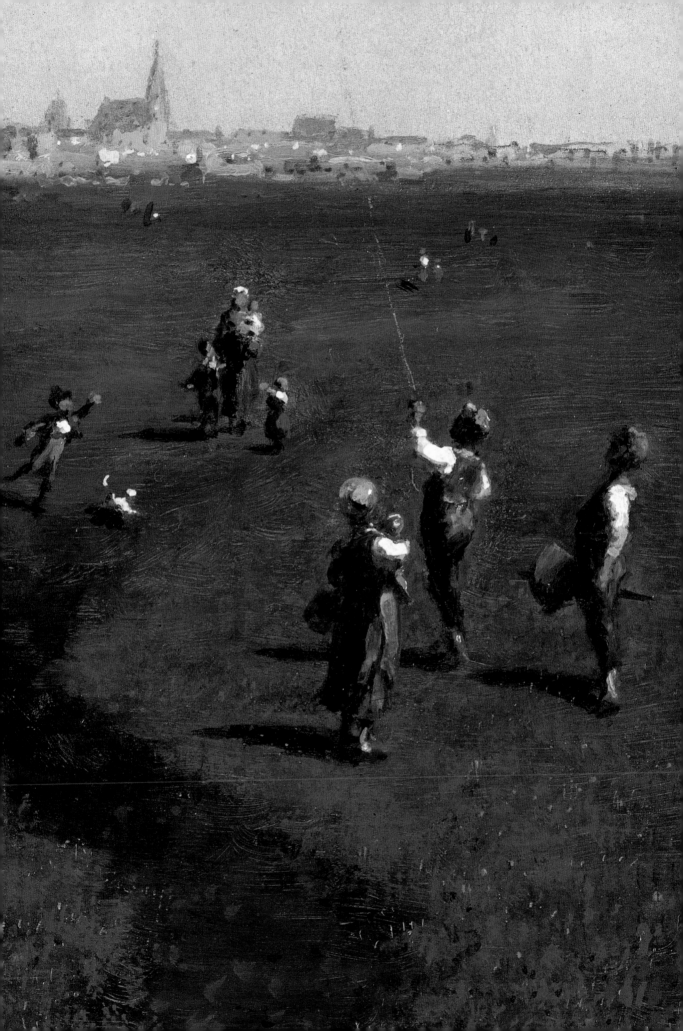

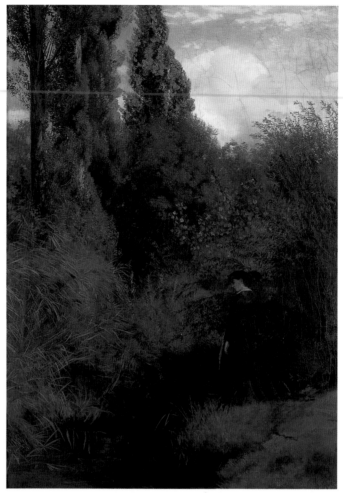

124

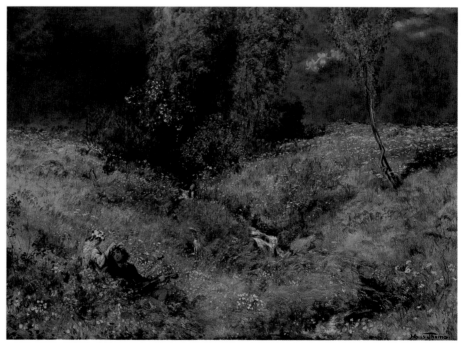

125

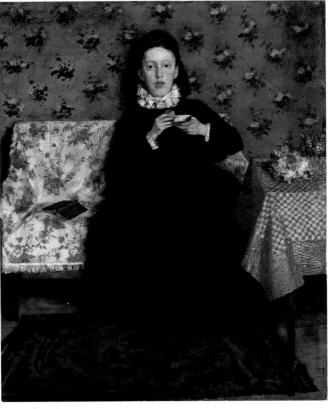

126

124
Hans Thoma
1839 Bernau im Schwarzwald–1924
Karlsruhe
Marsh on the Rhine, 1869
Oil on canvas, 103 × 75 cm
Acquired in 1922 through an
exchange with the painter
Hermann Schumm

From the mysterious darkness of
the vegetation – a tapestry of green
and brown – emerges a sombrely
dressed woman, turned away from
the viewer. It is as if she embodies
the soul of the landscape – or vice
versa. Böcklin and Feuerbach were,
at that time, working in a similar
way, as was Courbet in France,
whom Thoma had deeply admired.
In the spring of 1868 he spent
several weeks in Paris, where he
saw a large exhibition organised by
Courbet himself, and he visited
him in his studio. *Marsh on the
Rhine* is the painting of Thoma's
that most strongly shows Courbet's
influence.

125
Hans Thoma
1839 Bernau im Schwarzwald–1924
Karlsruhe
Summer, 1872
Oil on canvas, 76 × 104 cm
Puchased in 1926 from a private
owner

In the glowing, deep-blue sky, a
few tiny clouds have taken on
the form of dancing *amoretti*. A
garlanded couple in Renaissance
dress sits on the grass, the man
singing and playing the lute.
Thoma has painted a summer
landscape in bloom, a meadow
with a bubbling brook, crowned by
a cluster of bushes and trees; and
with these figures that appear from
another time, he has elevated this
pure description of nature to a
dreamlike unreality.

126
Wilhelm Trübner
1851 Heidelberg–1917 Karlsruhe
On the Sofa, 1872
Oil on canvas, 52 × 45 cm
Purchased from the artist in 1899

The young woman sits on the sofa,
eating bread and seeming quietly
self-assured. Like a large black
stain, her dress spreads across the
middle of the painting, reinforcing
the effect of the small coloured
details in her surroundings: the
patterned carpet, the red-check
tablecloth, the wallpaper with the
blue cornflowers, the sofa cover
with the red posies and the colour-
ful flurry of the flowers on the
table. Trübner had seen this frontal
close-up view of the figure in the
works of the admired Wilhelm
Leibl, but the young painter,
the son of a goldsmith, has
arranged his picture like a still life,
taking visible pleasure in rich and
precious colour.

From Naturalism to the *Fin de Siècle*

The decades between the founding of the German Empire in 1871 and the outbreak of the First World War in 1914 were marked by great artistic diversity and cannot be adequately described in terms of art-historical styles or periods. In each case terms such as 'Art of the *Gründerzeit*', 'German Impressionism', 'Naturalism', 'Symbolism' or '*Jugendstil*' reduce diverse phenomena to conformity with a narrow conception.

In the late nineteenth century, Anton von Werner, Hans Makart and Franz von Lenbach produced a state-supporting art through formal portraits of rulers and multi-figured history paintings. Widely disseminated too were markedly narrative genre paintings, landscape, and the battle and history paintings, which were well-represented at academy exhibitions, whose patriotic subjects were intended both to entertain and to propagate the self-understanding of the *Gründerzeit*.

Max Liebermann, then still very young, created his intimate *Cobbler's Workshop* as an idyll and *The Flax Spinners* as a depiction of industrious country life. Light and paint became the most important subject of the painting, while narrative was relegated to the background and social criticism generally excluded. Closer inspection shows how important were the differences between this and French Impressionism. Despite all the affinities in the light, the fluid brushwork and the concern with highlights and other light-effects, the Germans had a more complicated view of the world, darker in palette and mood. The difference is clearly visible, for example, in a comparison of Renoir's *Children's Afternoon at Wargemont* with Corinth's *The Family of the Painter Fritz Rumpf*. While the Frenchman peoples his luminous interior with interrelated figures, the German broods over an all-too-silent human association.

As the first open-minded German private collectors were buying modern art, including (for the first time) even the French Impressionists and the sculpture of Constantin Meunier and Auguste Rodin, Kaiser Wilhelm II – whose tastes were conservative but who dabbled in matters artistic with undiminished enthusiasm – held this kind of art in scorn. He forced the resignation of one of its most important champions, Hugo von Tschudi, then director of the Nationalgalerie, because he had supported Manet and Cézanne, Monet and Renoir. But the Kaiser pronounced the same scathing verdict on German artists like Walter Leitikow, misunderstanding and dismissing the formal ambitions of the latter's *Grunewaldsee* of 1895 (acquired by the Nationalgalerie in 1898) as lacking in verisimilitude.

Such reviled outsiders – whose work was described as 'gutter art' for failing to meet the obligations of pathos and social prestige – organised themselves into 'secessions': alternative and

oppositional artists' groups, such as were founded in Munich in 1892 and – following the dispute about Leistikow's painting – in Berlin in 1898, in which painters, graphic artists and sculptors were all represented. Only a decade later, however, their members had joined the established artists, so that in 1910 there was already a split, with artists like Ernst Ludwig Kirchner and Karl Schmidt-Rottluff joining the New Secession, and four years later, in 1914, there emerged the Free Secession, with the generation of Barlach, Meider and Lehmbruck.

One of the characteristics of this eventful and cosmopolitan time was that artists would work in more than one discipline. So Franz von Stuck, alongside his playfully mythological paintings and subtly dramatic portraits, also produced a number of sculptures, both life-size and statuettes; and the sculptor Adolf Hildebrand also painted and occasionally ventured into architecture and design. An artist who ranged over every field, from stove tiles, murals and panel paintings to graphics and polychrome sculpture, was Max Klinger, one of the great individualists of Symbolism.

The entire development of art had accelerated, fanning out, as it were, into countless individual fields, as is shown by even a cursory survey of the works in the Nationalgalerie that were produced between 1905 and 1912. Alongside the young Max Beckmann – clearly on his way to an expressive style schooled by Edvard Munch, with his existential subject matter and vehement compositions – is the older Franz von Stuck, who represented the *fin de siècle,* and also Max Slevogt, whose Impressionistic paintings seem effortless. From the Munich School there are artists as diverse as Giorgio de Chirico and Lovis Corinth, the first arriving at *Pittura Metafisica* with its enigmatic moods and provocative perspective, whilst the second worked towards a condensed, pre-Expressionist intensity.

While reproductions of Böcklin and Thoma adorned middle-class drawing rooms, the young artists of the Expressionist generation were already creating new groups, conscious of their outsider status and determined on a radical renewal of art. 'Die Brücke' was established in Dresden in 1905; the 'Blaue Reiter' followed in Munich in 1911. As these began their triumphant advance through the first open-minded galleries, the art of Stuck's and Liebermann's generation, which voiced the repletion of pre-war bourgeoisie, had already progressed from critical acceptance to the pedestal of universal acclaim. It is precisely this multiplication of dissimilarities that gives the period around 1900 its particular interest.

Bernhard Maaz

127

Max Liebermann
1847–1935 Berlin
Cobbler's Workshop, 1881
Oil on wood, 64 × 80 cm
Purchased in 1899 from the Faure
Collection, Paris

Extricating himself from the darker
register of naturalistic painting, in
this depiction of a busy cobbler's
workshop Max Liebermann
combines a summery, opalescent
landscape of pure bright colour
outside the window with an
interior restricted to a grey-brown
palette. These two elements, so
differently executed, are united in
the precise observation of light
in all its varied effects: outside, a
hazy non-directional light; inside,
a refulgent complexity of glint,
gleam and sheen.

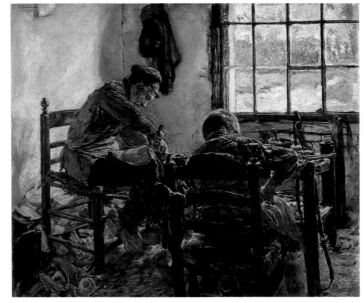

127

128

Max Liebermann
1847–1935 Berlin
The Flax Spinners, 1887
Oil on canvas, 135 × 232 cm
Gift of the artist, 1888

Within the sonorous harmony of
the grey-blue-brown is disclosed a
painting of the greatest nuance,
subtly articulating the individual
elements – the whirring flywheels,
the shuffling clogs, the industrious
activity – within the receding
depths of the interior. Liebermann
would rarely again display such
a refined grasp of subtle tonal
gradation, something he may have
realised when, not so long after
painting it, he donated this picture
to the Nationalgalerie.

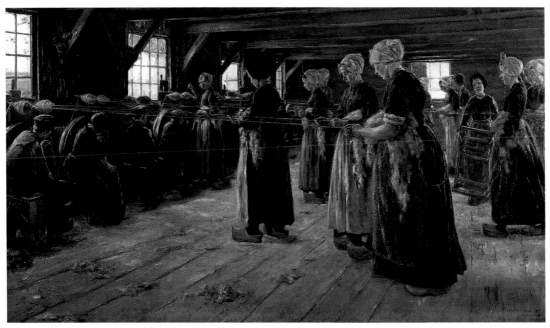

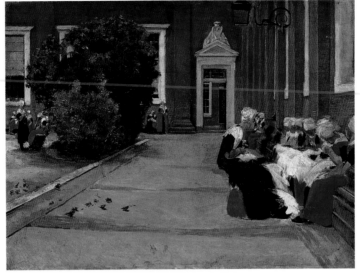

129

129

Max Liebermann
1847–1935 Berlin
Amsterdam Orphan Girls, 1876
Oil on canvas, 64.5 × 88 cm
Purchased in 1923 from Wilhelm
von Bode

Domestic architecture and
figures in dialogue, two traditional
subjects from 17th-century Dutch
painting, are here elegantly com-
bined and refigured in fluid,
modern brushwork. There is also
a humorous twist in the juxta-
position of the orphan girls on
one side and the fluttering
sparrows on the other.

130

Fritz von Uhde
1848 Wolkenburg/Zwickau–1911
Munich
Little Heathland Princess, 1889
Oil on canvas, 140 × 111 cm
Purchased in 1934 from Adolf
Kohner

A picture of paradisal simplicity.
Light, air and childish innocence
combine to produce an imaginary,
timeless idyll of country childhood:
a transfiguration that betrays the
nostalgic longings and poeticising
tendencies of the city-dweller.

131
Fritz von Uhde
1848, Wolkenburg/Zwickau–1911
Munich
Grace (Come, Lord Jesus, be our Guest), 1885
Oil on canvas, 130 × 165 cm
Purchased in 1886 from Fritz
Gurlitt, Berlin

Using a device possibly adapted
from Rembrandt, Uhde brings an
age-old biblical scene into his
present, giving dignity to the
poverty that is not merely the
chosen subject of the picture. For
a long time established as an aca-
demic art of decoration and social
prestige, history painting has here
regained a deeper, human meaning
by imbuing biblical events and
their associated religious ideas
with a contemporary resonance.

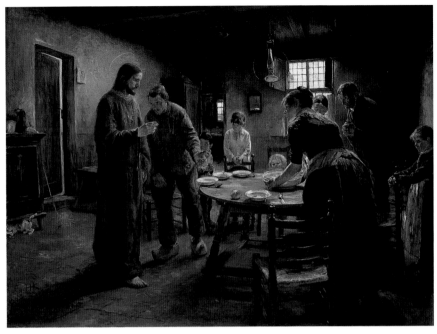

131

132
Lesser Ury
1861 Birnbaum/Posen–1931 Berlin
Estaminet (Flemish Tavern), 1884
Oil on canvas, 100.5 × 52 cm
Acquired by exchange in 1923

With its laconic figures, flat
modular construction, rigorous
composition and earthy colour,
this is a work of great painterly
sophistication, whose regal
abstraction from time and
place points ahead to Oskar
Schlemmer's figurine paintings.

132

133

133
Max Klinger
1857 Leipzig–1920 Großjena/
Naumburg
A Walker (Ambush), 1878
Oil on wood, 37 × 86 cm
Purchased in 1933 from Hermann
Fliess, Berlin

A short story, its beginning and
end unknown, has arrived at a
turning point: death or resistance?
The wall, painted with disturbing
precision, radically excludes a third
possibility: deliverance.

134

134
Constantin Meunier
1831 Etterbeck/Brussels–1905
Elsen/Brussels
Miners Returning Home, c.1895/97
Bronze, 67 × 92 × 6 cm
Gift of an anonymous Berlin
art lover, 1898

Meunier's lifelong concern was the
depiction of heavy physical work,
until then hardly ever represented
in sculpture, which he treated with
the same sense of respect as did
his countryman, the poet Emile
Verhaeren. Here there is no denun-
ciation, but simply an acknowledg-
ment. A perspective that calls
not for class struggle but for
empathy, in so doing at least
making possible the utopian
transfiguration of the fiercest
social conflict.

135

135

Max Klinger
1857 Leipzig–1920 Großjena/
Naumburg
Amphitrite, 1895–99
Marble, 178 × 47 × 42 cm
Donated by the heirs of Felix
Koenigs, Berlin, 1901

A challenging gaze, a self-
celebratory, proudly assertive
femininity and physicality – is
this a sea-goddess or society lady?
Klinger's Symbolist ambivalence –
the modern torsion that comes
from Rodin, the combination of
different marbles that was typical
of the period, and the only
partially preserved polychrome
treatment of the surface – all these
produce a multiple but ambigu-
ously interrelated medley in the
spirit of the *fin de siècle*.

136

136

Max Slevogt
1868 Landshut–1932 Neukastel/Pfalz
*The Singer Francisco d'Andrade as
Don Giovanni*, 1912
Oil on canvas, 210 × 170 cm
Purchased from the artist in 1913

The painter sings the singer, the
colours celebrate the music and
Slevogt pays homage to Mozart,
his favourite composer. Slevogt
had been a lover of his music for
decades. He painted several
portraits of d'Andrade as Don
Giovanni, a role for which the
now 50-year-old baritone was
especially famous.

137

Franz von Stuck

1863 Tettenweis/Niederbayern–1928
Munich

Self-portrait at the Easel, 1905

Oil on wood, 72 × 76 cm

On loan from the German Federal
Republic

Ennobled the year this picture was
painted, von Stuck displays the
well-fed, well-dressed pride of a
complacent bank director in an
opulent neo-Renaissance interior.
The palette is depicted in the
shade, the end of the brush
directed at the female nude; Eros
and success define the existence
of the 42-year-old Munich painter.

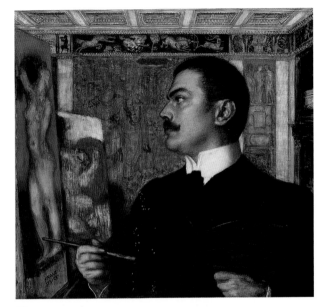

137

138

Franz von Stuck

1863 Tettenweis/Niederbayern–1928
Munich

*Sin, c.*1912

Oil on canvas, 88 × 52 cm

Painting on loan from the German
Federal Republic; frame on loan
from the Museum Villa Stuck

Desire tempted, desire disguised,
concealed, denied, desire feared.
Sin – a contemporary Eve with
snake, exceedingly feminine and
chic; von Stuck here rises up on a
golden altar to desire's decadent
excess.

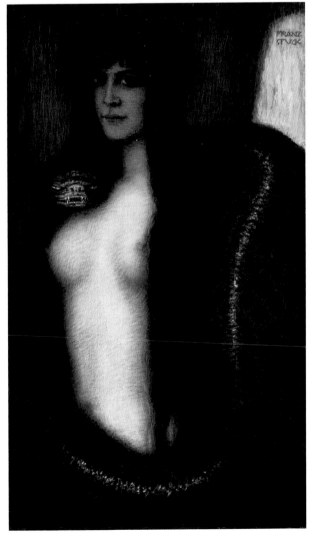

138

139

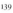

139
Lovis Corinth
1858 Tapiau, East Prussia–1925
Zandvoort, Holland
The Family of the Painter Fritz Rumpf, 1901
Oil on canvas, 113 × 140 cm
Purchased 1927 from the Rumpf family

In this painting, Lovis Corinth has turned to the group portrait, a genre with a rich tradition, but he has individualised the family members in a disturbing way, grouping the children alone or in pairs around the empty centre, so isolating them in space and attitude. Why is the father's figure missing? A psychology of the family presented with colouristic bravura, only a few years after Sigmund Freud's early works.

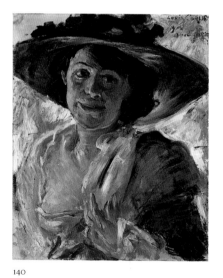

140

140
Lovis Corinth
1858 Tapiau, East Prussia–1925
Zandvoort, Holland
Woman in a Rose-Trimmed Hat, 1912
Oil on canvas, 60 × 50 cm
Purchased in 1952 from Kunsthandlung Klever, Berlin

This is Corinth's wife, painted in Italy during the artist's convalescence. The summery cheerfulness, Rubensesque vitality, brilliant handling of light and lively painting combine to impart this picture with a radiant zest for life, its happiness troubled only by the shadow of concern in the eyes and the tension in the mouth.

142
Giovanni Segantini
1858 Arco/Trient–1899 Schafberg/ St Moritz
Returning Home, 1895
Oil on canvas, 161.5 × 299 cm
Donated by the heirs of Felix Koenigs, Berlin, 1901

Between the distant church spire on one side and the hut on the other, in meticulous dots of colour Segantini has composed a high meadow in the Alps, across whose emptiness a small, dark, stolid funeral procession makes its way from right to left, as sad as it is lonely. Transient humanity meets the unshakeable strength of the mountains, and as it returns to eternal nothingness, finds consolation in the embrace of that familiar land, despite the grief.

141

Lovis Corinth

1858 Tapiau, East Prussia–1925 Zandvoort, Holland

Samson Blinded, 1912

Oil on canvas, 130 × 105 cm

Purchased in 1980 from a private owner

Painted a year after the stroke that Corinth suffered at the crowning moment of his career, this picture touches on the vulnerability of the strong and powerful. Samson, robbed by Delilah of his strength-giving hair, is taken prisoner and blinded. Later, in a frenzied state he destroys the temple; the experience of powerlessness and agonised revolt against it are combined in a furious depiction of wild, desperate pain.

141

143

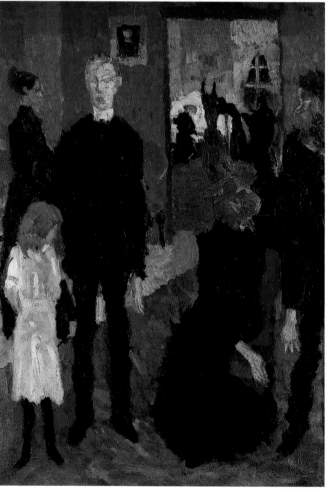

144

143
Giorgio de Chirico
1888 Volos, Greece–1978 Rome
Serenade, 1910
Oil on canvas, 82 × 120 cm
Acquired by exchange in 1932

This painting by the young de Chirico stands between his Munich training and his deliberately provocative series of paintings: *Pittura Metafisica*. It fuses together dream-dance, poetry and musicality, cultural quotation and elegy for nature, the sound of the lute and the murmur of fountains. His teacher Arnold Böcklin's concept of mystical mood and mythical subject in equilibrium is here sublimated, divested of any concrete reference and is raised to the beauty of a timeless world-weariness.

144
Max Beckmann
1884 Leipzig–1950 New York
Small Death Scene, 1906
Oil on canvas, 117 × 71 cm
Purchased 1952 from Galerie Meta Nierendorf, Berlin

Shadow theatre and Strindberg drama, house of mourning and ghost sonata – the figures seem pantomime-like, pale-faced and moribund, lost in desolate melancholy. Beckmann's mother died in 1906, the year he painted this picture – related to Edvard Munch's death scenes – and within a decade the supposedly ideal world of the old Europe had died too.

Ground Plan

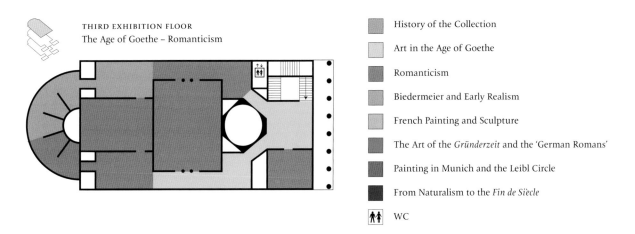
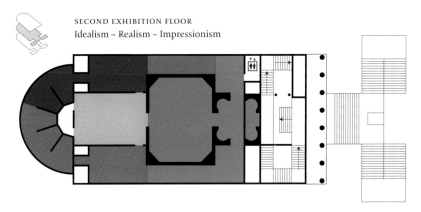

SECOND EXHIBITION FLOOR
Idealism – Realism – Impressionism

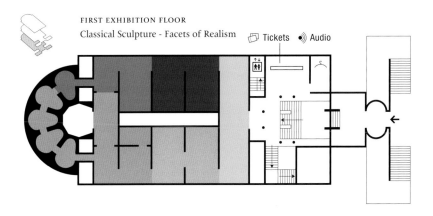

FIRST EXHIBITION FLOOR
Classical Sculpture - Facets of Realism

Tickets •)) Audio

Index of Artists

FURTHER READING

Nationalgalerie Berlin. Das XIX. Jahrhundert. Katalog der ausgestellten Werke. ed. Angelika Wesenberg and Eve Förschl, Berlin and Leipzig 2001

Nationalgalerie. Gesamtverzeichnis der Gemälde und Skulpturen (Catalogue of Painting and Sculpture), Staatliche Museen zu Berlin 1999 (CD-ROM, Diskus Series 015) Also available on the Internet at www.bildindex.de